A Third Naturalist's Guide
to Lakeland Waterfalls
throughout the year

E

First Published November 1987

ISBN 0 902272 73 X

Printed and published by
Westmorland Gazette, Kendal, England.

A Third Naturalist's Guide to Lakeland Waterfalls throughout the year

By Mary Welsh

Contents

Contents *(Continued)*

Book Three

NORTH EAST LAKELAND

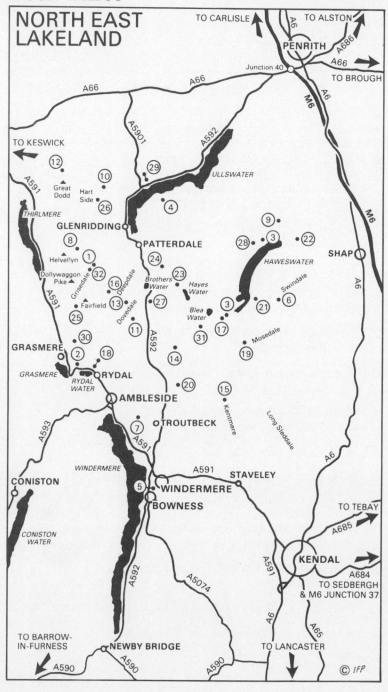

Foreword

Book Three of this series of Lakeland waterfalls encompasses the North East. In each chapter I have described the route to the waterfall and, depending on the season, the flowers, birds, animals and insects seen. I have used the same format as in Book One (Southern Lakeland) and Book Two (the North West).

The inspiration for the series was Stanley Force, set in its magnificent gorge, which I visited soon after I started my love affair with the Lake District. I completed the full complement of falls for each book with a certain sadness but this soon gave way to the excitement of setting out in search of, as yet, undiscovered falls in another part of Lakeland.

Book Three has been a great delight to research and write. It has taken me to dramatic falls hidden high in remote fells where I have viewed nature's profligacy and glory alone; alone, that is, except for a chosen companion and my border collie Cammy. Other walkers head for the tops, leaving me to enjoy the seclusion and peace of the gills and I hope my readers will enjoy searching for these secret corners of rare beauty.

I am very grateful to David Macaulay for illustrating Books Two and Three. He will also illustrate Book Four in which will be found all those lonely, spectacular falls that I have been unable to include in the earlier books. His exquisite drawings have caught the charm and magic that I have sought to portray with my pen.

Waterfalls on Nethermostcove Beck, Grisedale

Waterfalls on Nethermostcove Beck, Grisedale

Park in the large car park in the village of Glenridding at the southern end of Ullswater. Return to the A592 and walk south, crossing Glenridding Bridge. Turn right immediately after the bridge and walk past the cluster of shops and the village hall to a gate. Beyond lies a cart-track, with a low wall on the right and the Glenridding Beck racing furiously over its stony bed below. To the left are young silver birch with buds still tightly closed in the grip of winter.

Bear left at the slate sign to Lanty's Tarn and Grisedale and continue along the track past the last cottage to a wooden footbridge that crosses a tiny stream on the left of the track. A frozen footpath leads from the bridge straight up a wooded slope where marsh tit call 'cheevi, cheevi, cheevi' from the birch, alder, ash and oak that crowd the steep hillside. Above the tree canopy the sky is very blue and a flock of wood pigeons fly across a gap in the trees.

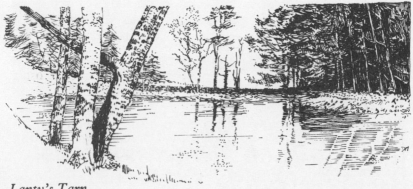

Lanty's Tarn

The path then makes a detour around a small plantation of oak saplings to a gate and the open fell. A signpost shows the way, encouraging the walker to keep to the zig-zag path which avoids the badly eroded old tracks. Look from this path to Ullswater lying below, a tranquil sheet of water reflecting the surrounding fells and with just a hint of mist.

Pines on Keldas

At 11 a.m. in early January this path is bathed in sunlight and the warmth of the sun is welcome after the intense cold of the shade thrown by the trees and the slope itself. The sun-bathed path leads to Lanty's Tarn. To the left are the striking Scots pine that adorn Keldas — a height that gives splendid views of Ullswater.

A kissing gate gives access to a path beside the little tarn now covered with thick ice. To the right a dense stand of larch hosts more marsh tit. Scots pine border the left bank of the tarn. The path moves away from the water's edge and into a copse of silver birch alive with the calls of blue and coal tit. Follow the path as it drops downhill. A dense layer of frost covers foxglove leaves but the pines to the left are in full sun and goldcrest call quietly to each other as they search the dark green needles. A pair of red squirrels are out and about too. One sits on a sun-warmed oak, occasionally disappearing into a large rock crevice and then returning to continue sunbathing, the second races up a trunk then leaps from branch to branch making each needle-laden twig sway momentarily.

Below, in deep shade cast by Thornhow Crag, Grisedale lies dark and still and covered with frost. Walk along the well-signposted path to another kissing gate set in a wall. Here in the leafless trees the sharp 'zit' call of a tree creeper is heard and then it flies overhead, settling at the base of an oak to work its way upwards searching for insects. It is joined by another and together they fly off to probe the trees on the slope above. Coal tit search through the litter beneath the trees and a hen blackbird noisily warns of intruders.

Keep to the path that runs parallel with the wall. The fell slopes to the right are covered with dead bracken but in the bright sunlight this glows a rich, warm, living red. The peace of the deserted valley is suddenly shatttered as the foxhounds cross at Thornhow End. Follow the path through a sturdy, iron gate with a large, solid latch. Below lies Braesteads Farm, just in the sunlight, with the smoke from its chimney drifting into the cloudless sky. Now the path is wide and grassy and a delight to walk along. A row of stately pines to the left, with a full complement of goldcrest, cast a dense shade that makes the walker hurry along anxious to regain the warmth of the sun. A series of tiny becks bisect the path, much of their water turning to ice instead of rushing down the fell to join the Grisedale.

Now the sun is obscured by St. Sunday Crag and the path is once more plunged into shade. No longer dazzled by the bright light, the walker can see the huge boulders scattered across the fell, many patchworked with olive-yellow lichen. Above to the right are the scree slopes of Grisedale Brow and ahead lie huge humps of glacial moraine. Another ancient iron gate leads the walker once more into the sunshine. From here Grisedale Beck can be seen — a ribbon of silver running through the valley bottom.

Away to the right lie the waterfalls on the Nethermostcove Beck, a mass of white ice for all its length. The footpath crosses the beck and leads to another kissing gate. Beyond this, turn right and for a hundred yards climb a sheep trod that keeps close to a wall and brings the walker to the bottom of the waterfalls in all their frozen glory. The beck's impetuosity has been held and fixed in ice. Occasionally the boisterous water has broken through and it chuckles with its success. The cascades caught by the

Marsh tit on larch

freezing wind have been piled up into frozen foam and beautiful crystal shapes. Icy pools with turquoise centres where the sun has had some effect have frozen waves around their edges. Long sparkling icicles hang from rock faces and beneath a scrubby hawthorn delicate ice shapes frame a tiny fall of water that has escaped its restraining ice.

Climb up beside the beck to more falls above, where the beck can be seen bubbling beneath its frozen surface, and then continue steeply upwards into Nethermost Cove. Here the walker feels quite alone, but high up on the right tiny figures step out along Striding Edge, voices travel on the clear air from climbers on Eagle Crag and in the far distance a skier races across a snow-covered slope.

O.S. Map NY354145
7 miles

Waterfall on White Moss Common and walk around Rydal Water

There is ample parking on either side of the A591 at White Moss Common. Birch and oak screen the cars and from these trees robin, blue tit and chaffinch hurry to greet the motorist on a cold January day. A dusting of snow softens the ground and makes the breasts of the robins appear brilliantly red. One robin settles on the bonnet of the car and another scurries beneath, 'ticking' as it goes.

At the east end of the car park a small beck hurries merrily through oak, sycamore, birch and holly. A black-headed gull, in winter plumage, sits on the footpath signpost unconcerned by passers-by. Blackbirds sort through the oak litter beneath the trees hunting for overwintering insects. A pair of mallards rise to shoulder height and fly across the road towards the River Rothay as the walker approaches. The catkins on the birch lining the beck, though stiff and small, are flushed with green.

Progress along the south-east side of the beck to the foot of the charming waterfall — the focal point of the walk coming right at the beginning of the excursion. Foaming, white-topped, the beck divides into two plumes of sparkling water, as it races round a lichened boulder. Beneath this obstruction the raging beck gathers its water into one long fall that sends spray into the wintry sunshine, sparkling and twinkling as it goes. It drops into a boiling pool and then chuckles noisily over its pebbly bed on its way to join the river and the lake.

Moss, polypody and other ferns push their way through the thin layer of snow on either side of the beck. Layers of ice cover

the flat surfaces of the precipice that has caused the little beck to make its dramatic descent. Bramble bushes crowd one side of the bank and a mature holly leans over the water, the leaves of both adding a welcome touch of green, contrasting sharply with the brown and white all around.

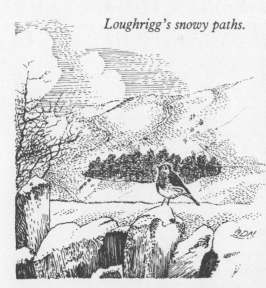

Loughrigg's snowy paths.

Walk on from the fall bearing slightly to the right, following a track that passes between drystone walls with the tiny beck to the immediate right. Pass through a gate, pausing a while to look down through the bare trees to Rydal Water. Among the trees a roe deer feeds quietly. It soon senses the walker's presence and off it bounds deeper into the woodland. Follow the track until it comes to the front of two cottages. Here turn right, passing through a gate onto a track with beech and oak to the left and a tall drystone wall to the right. From here there is a good view of Loughrigg, with its maze of snowy paths, white lines through the brown bracken. Loughrigg Terrace, another long, white slash, stands out clear and straight in the sunshine.

The woodland soon gives way to the open fell — the slopes of Nab Scar. Just beyond a huge sycamore, which in summer gives dense shade to the path, is a gate in a wall which leads into ancient oak woodland. These trees are gnarled and twisted and many are festooned with opportunist polypody growing in any crevice that it can. The next gate opens into a meadow that slopes down to the road and to the lake. The water is covered with ice and the trees on Little Isle and Heron Isle are topped with snow.

Pass through the next wall by a gap where there was once a gate. Now the path, bordered with wide grassy slopes, leads to

another gate beyond which are huge, gnarled ash, well spaced, their trunks pale grey in the soft sunlight. Another gate gives access to a walled track and from here can be heard the wrangling of gulls over the frozen lake. Turn right where the path meets the road and walk downhill past Rydal Mount, Wordsworth's last home. Here a rhododendron flowers and blue tit chuckle as they flit across the road.

Further down the slope is St. Mary's Church, where the laurel bushes are in blossom, great tit call and the churchyard walls are bright green with delicate spleenwort fern. When the A591 is reached turn right, cross the road and walk along the footpath for fifty yards. Opposite the Rothay Hotel a breach in the wall reveals a footpath to a wooden bridge over the swirling water of the River Rothay. Bear right beyond the gate into a pasture where pigeon and crow hunt for food. A green woodpecker flies with an easy, bounding flight across the path and alights on a nearby oak, ascending with quick, jerky jumps.

A kissing gate gives entrance to Rydal Woods and here a jay screeches harshly and mistle thrush noisily fly from one hip-laden bush to another. Pass through the gate at the edge of the wood and keep to the path that borders the lake. Here, in a tiny patch of unfrozen water, a jackdaw bathes noisily, unworried by the cold. Continue beside the lake and then follow the signposted track for White Moss Common.

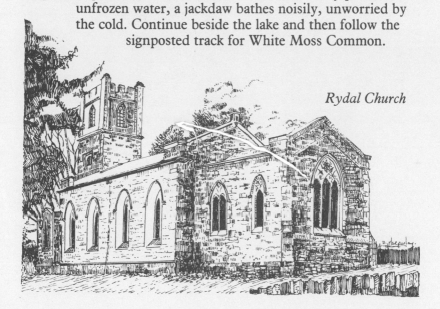

Rydal Church

9

When the wood at the end of the lake is
reached, look for a gate in the wall and walk
downhill through the trees. The lovely path
comes to the edge of the Rothay. Stand on the
footbridge and watch a dipper running into
the water after insects. Regularly it bobs up
to the surface and then disappears
once more.

Pass through the birch to
cross the main road; ahead is
the pretty waterfall enjoyed at
the start of the walk.

*Spleenwort fern and blackbird
in forest litter.*

O.S. Map NY350067
4 miles

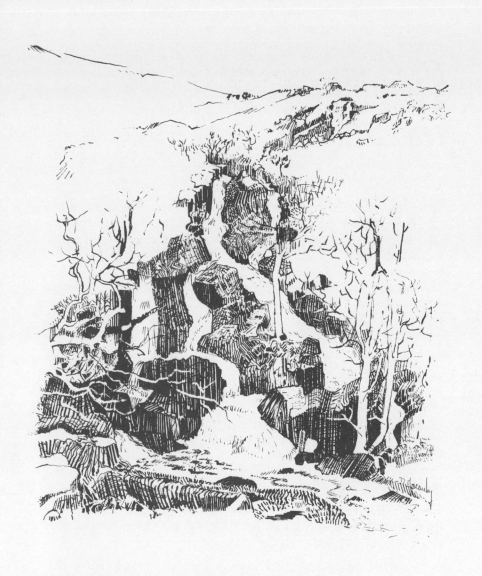

Dodderwick Force and the Measand Beck Forces, Haweswater

Dodderwick Force and the Measand Beck Forces, Haweswater

I t is a marvellous experience to walk along the west shore of Haweswater on one of those rare February days when the sun shines continuously and spring seems to have arrived. The path sometimes hugs the lake and at other times rises to give a bird's-eye view of this tranquil stretch of water. From any part of the walk the beauty and seclusion is tinged with a trace of sadness as drystone walls march down into the dark waters, reminding the walker that once a community lived and died in this valley before it was flooded to create a reservoir.

The A6 to Shap from Penrith or Kendal, flanked by bleak, barren fells, provides a severe approach to the lake. From Shap the road is signposted to Bampton Grange and the reservoir. Take time to look at Bampton Bridge, with its low parapets and recesses for avoiding traffic, and to enjoy the limestone walls made of much thinner slabs of rock than are used in other parts of the Lake District.

The road from Bampton keeps close to the east shore and terminates at Mardale Head, where there is a small car park. Here Harter Fell, still streaked with snow, grandly shelters the valley from westerly winds. Mardale Beck races down the mountain's easterly flank into a spur of the reservoir.

A short walk up the beck leads to the charming Dodderwick Force which falls as a foaming jet dropping between rocks patchworked with lichen. It then flows beneath two graceful birch, their red twigs and buds glowing richly in the noonday sun. On one side of the waterfall are grassy flats just made for day-dreaming but the walk to the Forces of Measand Beck is four and a half miles and the February daylight is notoriously short.

Dodderwick Force

Return to the path that crosses Mardale Beck and continue beside the lake. The track ceases to be stony and becomes a grassy swathe for much of the way. It is a pleasure to be able to walk and enjoy the rough fells. Here a kestrel enjoys the sun in a stunted bush before setting off in quest of food along the slopes of Laythwaite Crags. Over the water a buzzard takes advantage of the rising air currents and is soon lost to sight above Naddle Forest without resorting to any vigorous wing flapping.

Below the crags a mixed plantation of beech and pine is full of goldcrest, tit, mistle thrush and jay — the latter noisily objecting to the presence of the two raptors.

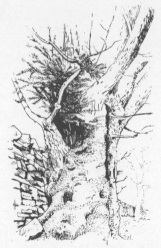

A yew tree rooted in an ash.

Close by the path, behind what remains of the fell wall, is a tall, sturdy ash of many decades. In a hollow between the main trunk and a stout branch a yew tree has rooted. Has it grown from a berry left by a hungry thrush and did it come from the fine yew that once graced the churchyard before the valley was flooded?

Regularly the path crosses gurgling becks hurrying down the slopes through tree-lined gullies. Some have white-capped fans of water, others are crossed by clapper bridges. All enchant the walker. But the greatest enchantment is the first view of the Forces, which tumble in many silvery cascades through a screen of grey-barked ash. Just above the path, the water divides into six races surging around huge boulders and rocky outcrops before it comes together to hurry through a birch and alder-clad defile to the reservoir.

On the return walk the sun is warm on the face and there is time to gaze at the encircling heights, each snow-filled gully a sharp-edged white patch against the dark rock-face The sun turns the water of the lake to an indescribable shade of purple. It catches the white wings of several hundred common gulls

Each snow-filled gully a sharp-edged white patch against the dark rock-face.

that have been flying in to roost as the shadows lengthen. Among them floats a handsome cormorant which then takes off and flies low over the rippling water, long neck outstretched, the white on its face and the yellow at the base of its bill catching the sun too.

Several immature golden-eye ducks idly attend to their toilet well away from the noisy gulls. Their big-headed appearance identifies them and, as one rolls to one side to preen a difficult

Common gull

feather, it shows its white side-feathers. These pied ducks then take off and fly up the lake in the wake of the cormorant.

The path back is in the direction taken by the duck and it is not until the shadows of the high fells and the car park are reached that the chattering of the restless gulls is no longer heard.

O.S. Map NY464105
 NY485155
8 miles

Scalehow Force, south side of Ullswater

Someone at some time built the path along the southern shore of Ullswater. It must have taken much effort and time but has since given immeasurable pleasure to the host of walkers who stride along it from Patterdale towards Howtown.

It is the path that leads to the waterfalls on the Scalehow Beck. On St. Valentine's Day these falls and all their tributaries are locked tight in ice. The small streams that come off the fells above, now frozen, unite in a peaceful hollow above the falls. Here at mid-day in February the sun shines warmly and this is the place for a picnic, well sheltered from the easterly winds. Below this point, the wind has frozen the formerly lively, chattering water courses and piled them into huge ice formations at the precipitous edge of this hanging valley.

The path that leads to the waterfalls.

All the way down its bed between the tit-haunted alder, the beck is a long, wide, white ribbon of ice. From the bottom it is a fearsome sight, with huge piles of creamy-white ice appearing to come down out of the sky.

On the fells behind the falls, the beagles are out and occasionally the air is rent with their mournful barks. But the hares are not around and the pack returns unsuccessful.

The fellside on this southern shore is covered with large boulders and here a fox slumbers the daylight hours away. The only evidence of his presence is cylindrical black droppings with twisted ends.

Fox droppings

The return walk along this path is pure delight. The sun is on one's face and the view of the lake, with the Helvellyn range to the right and the snow-clad Fairfield range ahead, is indescribably

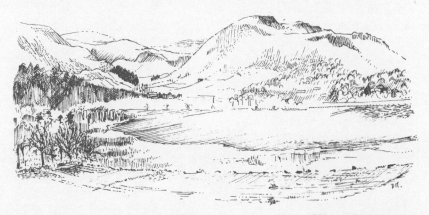

View of Ullswater

beautiful. It is best to dawdle back through the silver birch and juniper that cover the fellside from the top to the shoreline. On the lake, coot and tufted duck idle away the afternoon. Norfolk Island, although in full sunlight, is mostly covered in sheet ice and plays host to twenty-three cormorant sunbathers.

Blackcap

although in full sunlight, is mostly covered in sheet ice and plays host to twenty-three cormorant sunbathers.

To reach the lovely Scalehow Force, far from roads and traffic, park by the village hall in Patterdale and take the footpath, well signposted, behind it. The path is really a causeway that eventually crosses the Goldrill Beck, passing through Side Farm before turning left. On the outward journey, take the right fork onto the juniper-covered slopes behind Silver Crag, where fieldfares restlessly search for berries. Here too an unexpected visitor, a blackcap, serenades the sun with a high, thin, musical call-note.

On the return journey the lower path on the lake side of Silver Crag gives a good view of Ullswater. Here in the warm sun a gentle breeze pushes sheets of ice against the rocky shore and the air is full of the noise of cracking ice. Near the head of the lake, great reeds, trapped in the ice, are coloured gold by the sun.

O.S. Map NY414191
6½ miles

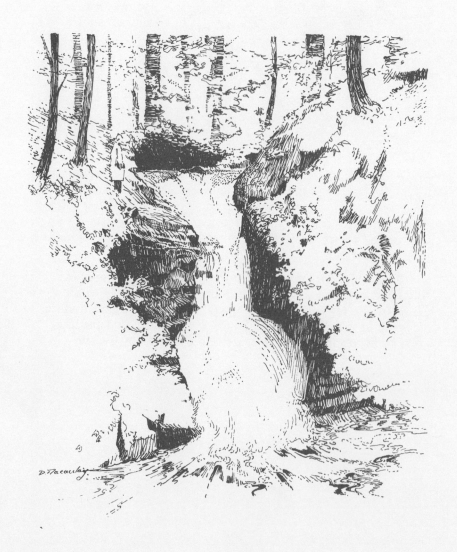

Rayrigg Cascades, Windermere

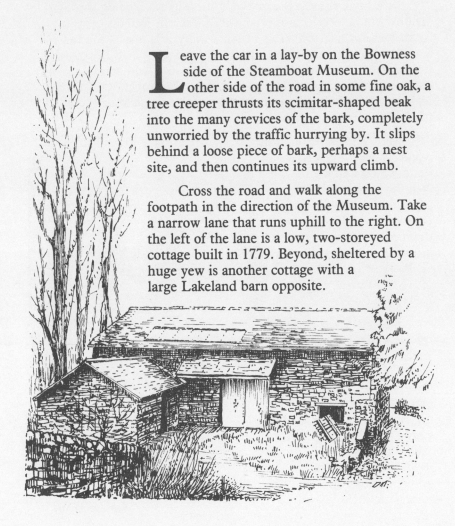

Leave the car in a lay-by on the Bowness side of the Steamboat Museum. On the other side of the road in some fine oak, a tree creeper thrusts its scimitar-shaped beak into the many crevices of the bark, completely unworried by the traffic hurrying by. It slips behind a loose piece of bark, perhaps a nest site, and then continues its upward climb.

Cross the road and walk along the footpath in the direction of the Museum. Take a narrow lane that runs uphill to the right. On the left of the lane is a low, two-storeyed cottage built in 1779. Beyond, sheltered by a huge yew is another cottage with a large Lakeland barn opposite.

Further on are a cluster of small cottages, their gardens full of snowdrops and aconites. Robin and chaffinch are now in full song, and a mistle thrush perched high in a tree sings strongly and continuously.

Behind the cottages Mill Beck hurries noisily downhill to the lake. At the end of the lane cross Longlands Road and enter the Millbeck Stock woodlands, following the footpath to the end of the wood.

Mill Beck rises to the east of Windermere, passing through Heathwaite before entering the woods. Here it gurgles over its rocky bed beneath some fine beech. Last year's leaves and mast litter the ground. Snowdrops grow close to the water's edge and ivy trails where it can. Hazel catkins hang long and pendulous and elder bushes are in leaf. Honeysuckle clambers over other shrubs, its leaves already having lost their early paleness and softness. A moth flits across the path.

Return back through the wood. Where the path is bounded by a drystone wall the beck tumbles through a narrow ravine. In the wall a plaque notes that the woods were a gift to the public by G. Pattinson, member of a well known Bowness family.

Beyond the ravine the beck divides and encircles a large, grassy island where bilberry and moss grow. Overhead are mature oak and many of their leaves lie underfoot. Through the leaves young beech trees thrust their way towards the light, their bronzed, pointed buds still tightly closed.

Hazel catkins and long-tailed tits.

22

The waters of the divided beck come together again in unusual twin falls, the Rayrigg Cascades, the highlight of the walk. The streams drop about thirteen feet and though not spectacular, their lively, foaming whiteness against the water-blackened rocks is charming.

Close to the racing water, liverwort luxuriate and algae thrive and boulders along the edge are moss covered. The waters come together and then set off along a narrow, deep channel to pass under Longlands Road, beneath a sturdy bridge.

Return to the road, turn right and walk through Rayrigg Wood. Here the birch, beech, oak and ash play host to courting tits. A pair of long-tailed tits continually call 'zee-up' to each other as they search for slumbering insects with acrobatic grace.

When the gate at the end of the road is in view, take a left turn into the wood. Polypody fern and bramble flourish but it is still too early for spring flowers. Follow the path as it swings around to the left, returning eventually to Longlands Road and the cheerful song of Mill Beck.

Bridge under Longlands Road.

O.S. Map SD406975
2 miles

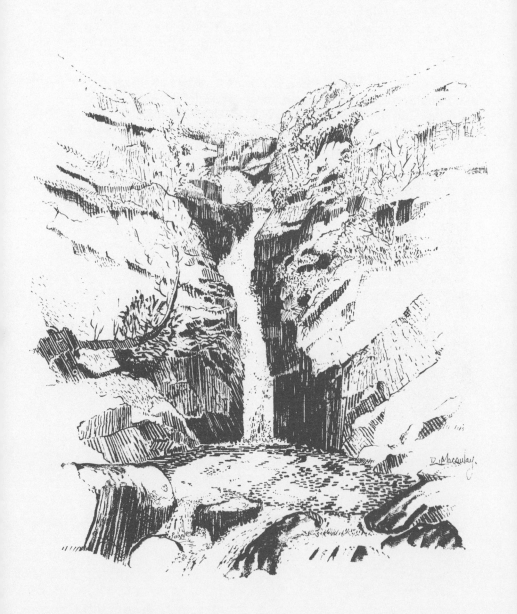

Forces Falls, Swindale

At Rosgill the young lambs, still very small, frolic, leaping over rocks and tree roots, pausing only for a drink or a short rest on their ewe's back. Just beyond this reminder that spring is on the way, the lane to Swindale leaves the road to Bampton, making an acute left-turn at Toathmain. It is an unfenced road and crosses Rosgill Moor where the first meadow pipits have arrived and are busily establishing their territories.

Just before the walled Swindale lane begins there is a flat, green area for parking and here another harbinger of spring is heard — the long, rippling whistle of an early sandpiper prospecting its reach on the Swindale Beck.

The lane is a joy to walk along. Chattering becks tumble down between hawthorn and hazel, the latter golden with fat catkins. Blue tit chuckle in the bushes and a canary-coloured yellowhammer advertises for a mate.

Yellowhammer

Another small fall hastens downhill at Swindale Head Farm. It keeps close to the old corpse-road over which, in the eighteenth century, bodies were carried from Mardale to Shap for burial. Close by the beck a grassy dell is carpeted with snowdrop, each white head catching the first rays of a watery sun. Here too

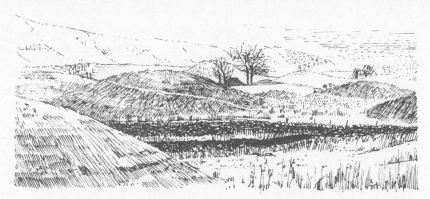

Splendid drumlins and dried-out tarn.

tree creepers hunt for insects, their "zit" call competing with the splashing beck and their silvery white undersides with the snowdrops.

A gate just beyond some ruined farm buildings admits the walker to an unmetalled track and to a first distant sighting of Forces Falls. From this view the eye is distracted by the splendid drumlins, by the huge Simon Stone, by the traces of a dried-out tarn and by the fearsome Hobgrumble Gill, which all lie immediately ahead. But these fascinating facets of Swindale should be savoured later and not allowed to distract from the main purpose of the walk — the Forces Falls.

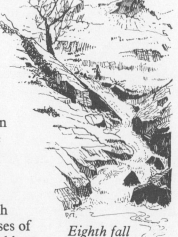

The beck takes nine spectacular leaps to leave Mosedale and fall into Swindale. The ninth jump, reached first, is made as a foam-covered jet and then a white fan of water falls into a brown pool cradled by silver birch. In these trees another migrant has arrived, a ring ousel, alert for a mate or an intruder to its territory.

Above, the beck makes its eighth plunge as a wide band of silvery tresses of water that slide over smooth, flat boulders, only to be noisily and angrily channelled into a narrow cleft.

Eighth fall

26

The seventh fall, a white and green streaked ribbon of water, occurs in a rocky part of the gill. Here a gnarled tree maintains its hold among the boulders. Its bark is cracked and its branches twisted, but its twigs transform the ancient tree into a thing of beauty, youth and vigour. It is a goat willow, loaded with silvery, woolly flower buds.

Where a sparkling line of water topples vertically down a very long, narrow fissure to join the Mosedale, the sixth waterfall occurs. This time the beck is divided into three cascades by huge rocks with one enormous boulder jutting up in the centre. Here, in rocks by the water's edge, myriads of pebbles have been swirled around by the current, wearing away the softer material and leaving perfectly rounded holes in the harder rock.

The next three falls are found in a very steep part of the ravine, and its perpendicular sides and the narrow space between make the imprisoned water fill the air with the noise of its fury.

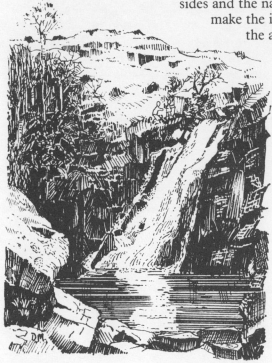

Sixth fall

The second fall reveals even larger tresses of tumbling water and is best viewed from the grassy slopes above. The first and most spectacular fall lies ahead. The water slips down from the heights above in a very long plume that is deflected to the left just before it tumbles into a dark pool fringed

with juniper. Here at the foot of this graceful fall is the place to eat one's snack, sheltered from the wind.

On the return journey there is time to enjoy the drumlins, to skirt the bed of the old tarn and to visit Hobgrumble Gill. Down this gil! a beck plummets for hundreds of feet, in a series of long, narrow falls. It drops down a vertical fault through silver birch, past hanging gardens of lush fern and moss, guarded by lichen-bedecked boulders. In one of the birch a kestrel rests after hunting prey over the slopes of Howes. This enormous fall of water, almost hidden from view in its narrow shaft, is well worth a visit but if the walker is to reach its top, he must be energetic to scramble up the moss-bound scree that clothes its flanks.

Hobgrumble Gill

O.S. Map NY477084
5 miles

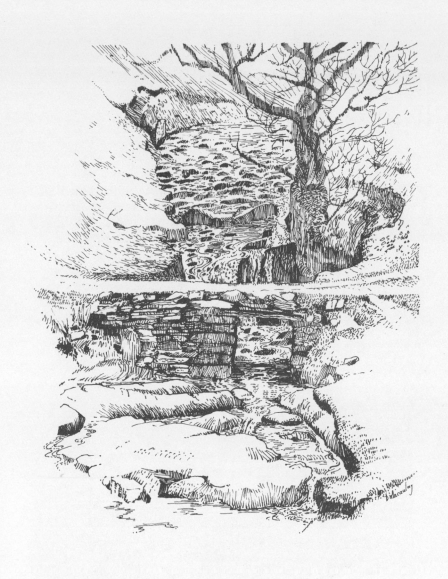

Waterfall on Hol Beck,
Wansfell

Waterfall on Hol Beck, Wansfell

olbeck Lane and Bridge Lane lead off the A591, which runs along the eastern shore of Windermere. Both lead to Troutbeck and both are bordered with drystone walls that are heavily covered with moss and several species of fern. They provide a delightful approach to the secluded village with its 17th and 18th century houses. Just beyond the junction of the two lanes is Town End, a farmhouse owned by the Browne family from the early 17th century until it was taken over by the National Trust in 1947. Further along the road is Troutbeck Post Office and outside this sturdy edifice it is usually possible to park.

Town End

Jay and alder

Look for the old sign-board high above the post office window directing the walker to Robin Lane and thence to Skelghyll Wood and Jenkin Crag. This rough, wide cart-track rises gently up the lower slopes of Wansfell. One side of the track is walled and the other has a hedge of hazel. In these trees are numerous blue tit and great tit now in full song. Chaffinch abound and they fill the early March air with their exuberant songs. A jay, pink bodied and with a white rump, flies low across the track and then rises to clear the wall and is away over the pasture to a clump of trees beyond. On the walls of the cottages on the right winter jasmine flowers and snowdrops, as white as the snow lying on the surrounding pastures, crowd the little gardens at the side of the track.

The track continues to climb gently leaving the houses behind. Jackdaws call raucously as they fly overhead and above circles a buzzard, the sunlight highlighting its handsome markings. The hazel are covered with golden catkins, now long and pendulous. Below, among the roots of the hedgerow trees, wild arum leaves, still tightly rolled, compete with foxglove leaves, which for so long have provided the only greenery.

Once the hedge is left behind, the snow-covered fell can be seen on either side of this quiet lane, now walled on both sides. The track continues to climb until it is joined by another walled lane coming up from Holbeck Lane. At the junction is a wooden seat perfectly positioned for enjoying the lines of the curving shores of the lake below. Windermere is silver in the bright sunshine and its surrounds are bleached of all colour.

The snowy pastures on either side are untrodden and unmarked. Nothing has disturbed the smooth, soft mantle of

white. The track, by contrast, is muddy. Yesterday the walls kept back the worst of the snow; today they trap the warmth of the sun, which turns the track into a quagmire. On the white fell above stands a strange pillar. Opposite, on the other side of the lane, another walled track comes up from Holbeck Lane. The drystone walls are a great feature of this walk. Striding over the fells, they border the tracks, they surmount humps, and they are all in good condition — a great tribute to the builders and to those who came after and maintained them.

On the left five fell ponies come to the wall expecting to be fed as they hear voices. Much of their pasture is under snow. Sheep too, come hurrying across the snowy field hoping to receive some fodder. The ponies, all in foal, have long manes which catch the wind and fringe their eyes. Their tails, long and bushy, are also wind blown. Just ahead of the next wall the path to Ambleside leads away to the left but the way to the waterfall lies straight ahead for three-quarters of a mile along a track called Hundreds Road.

This is a wonderful, high-level walk seemingly a long way from habitation and from other humans, and giving splendid views of the lake below. The track draws near to a gate, and tightly budded oak trees are seen over the wall. Beyond the gate, with snowy fells sloping upwards from the course of the Hol Beck,

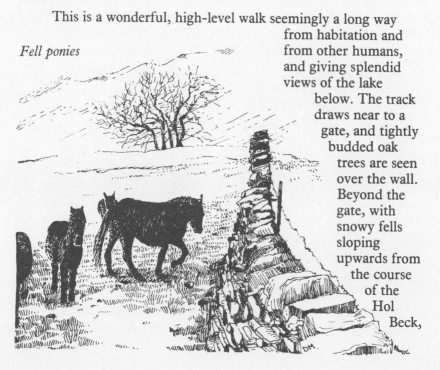

Fell ponies

32

lie the cascades. Foam-topped water dances down a gentle slope and then races beneath a huge oak, its trunk covered with the glossy green leaves of ivy. The water encircles moss-covered boulders that would slow its progress, and then, swirling around long icicles that hang down from the confining banks, it hurries under a charming drystone bridge.

A meadow pipit flies away from the edge of the beck leaving a trail of tiny footprints. A rabbit, too, has been down to the water's edge leaving tell-tale signs of its wanderings. Once under the little bridge the water rages on either side of a long, squat boulder laden with snow and with the brown stalks of bracken, bent double. Towards the end of its fall the beck makes a spectacular leap into the bottom of a little gorge, its spray-topped water sparkling in the afternoon sun. From here it idles along the bottom of the small, oak-lined ravine, iced in places and bubbling in others, and then is lost to sight as the gorge winds away to the west.

A charming drystone bridge.

O.S. Map NY399034
3½ miles

Waterfall on Red Tarn Beck, below Helvellyn

Park in the car park at Glenridding. In the trees scattered around the park chaffinch are now in full song and blackbirds face each other aggressively trying to ensure a territory for the busy nesting time ahead. Blue tit chuckle and great tit call metallically, advertising for a mate. The male flowers on the pussy willow are large, rounded and silvery. Spring seems very close in the village that hugs the shore of Ullswater.

Leave the car park following the signs for Helvellyn and turn left along the road passing the Travellers' Rest. Where the road swings uphill to the right, take the walled track that goes off to the left. Several oak and sycamore lean over the wall and in the pastures beyond jackdaw probe in the mud where sheep have trampled the turf.

At the end of the track bear right at a way-marked kissing gate signposted Greenside Mine. The footpath leads out into the pasture and then, as it begins to climb, the Glenridding Beck is seen below through beech and oak, both with buds tightly closed. On the right of the path the steep slopes below Blea Cove are covered with snow. On the far side of the beck Glenridding Screes are grey and formidable and

Pussy willow

without snow. Continue along the path to a stile which gives access to a footbridge over the beck. Below, the water tumbles in pretty, foam-topped falls. Above, the sky is blue and scudding clouds send shadows racing across the fells. The sun is warm but there is no sign of spring as the icy wind, sweeping down Greenside Road from the snowy tops ahead, buffets the walker.

Beyond the bridge, steps of pink rock lead up to a stile and a sign for Greenside Mine. Turn left and walk towards the old mine buildings, framed by a large conifer plantation on the left and a smaller one on the right. Below these trees the beck cascades. Just before the buildings look for the hillside where hundreds of logs are held in place by pegs. Each log holds back a small area of loose soil and this has been colonised by tough, bleached grass. In time the hillside will lose its bleak, desolate air and hopefully be covered with a carpet of green.

Once over the bridge that straddles the Swart Beck pass through a kissing gate. Beyond to the left is an Outdoor Centre and next to it Almond Lodge. Continue straight ahead and then with great care move to the edge of the steep ravine. Here, just above the buildings, the Glenridding Beck drops in a spectacular waterfall. It foams white topped around snow-covered impeding boulders and then hurtles downwards in a long, white fall. The sides of the narrow, dark canyon are lined with moss and polypody fern. Holly and birch lean over the raging water, the birch covered with tiny catkins.

Follow the path as it swings towards the next footbridge and then crosses the Glenridding. From here the walker gains his first view of the white tops of Catstycam and Helvellyn Little Man. Turn right over the

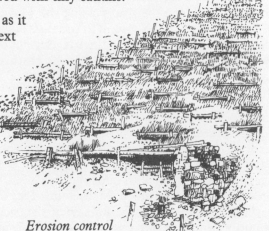

Erosion control

bridge and walk on along the frozen, snowy path beside the Glenridding. High above to the left the scree is softened with juniper. A pair of crows fly overhead wheeling and diving as if playing with the wind. Rowten Beck appears to breach the ridge top of Glenridding Common, leaping down the steep slopes, foam topped between glistening icicles.

Now the track begins to climb into a snowy wonderland. Icy blasts unsteady the walker. A footbridge over Red Tarn Beck makes a good viewing point for delightful falls above as they chuckle and hurry between the snowy slopes. The path, which has been reinforced to prevent erosion, swings up to the right, keeping close to the beck. Here and there pink rocks used for the path have lost their snow and glow warmly in the afternoon sun. The path climbs relentlessly upwards with Catstycam to the right casting a deep shade.

The object of the walk lies ahead. The waterfall drops within a frame of snow. Thick, frozen snow lies above, to either side and below. Only where the water hurtles is it free of imprisoning snow. The path comes quite close to the fall. Climb down the slope to some large rocks. They are out of the wind but in the sun and give a good view of the fall and a place to picnic. From this vantage point the walls of the fall are translucent and tinged with turquoise and long icicles sparkle in the wintry sun.

This may be the turning point of the walk or the walker may wish to continue on and up to a peaty plateau where only lichen seems to thrive. To the left brightly-dressed skiers race headlong

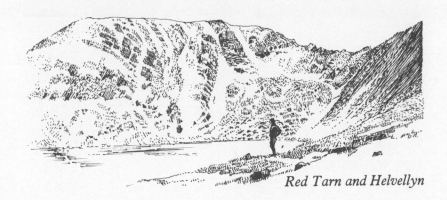

Red Tarn and Helvellyn

downhill below Striding Edge. Along the latter, small black figures struggle. To the right the path snakes uphill to the start of Swirral Edge and more figures battle against a fearsome wind. Ahead lies Red Tarn, covered with pale blue ice as it reflects the sky. Beyond, stretching upwards, is the almost sheer face of Helvellyn, a white, awesome giant. Here more tiny figures toil upwards, their efforts contrasting with the effortless frolics of the ravens that circle the top.

Where Red Tarn Beck issues from this quiet, deserted, sheltered hollow the ice is powdery and cracked, and through these fissures the lively beck bubbles on its way to join the Glenridding.

O.S. Map NY357159
7 miles

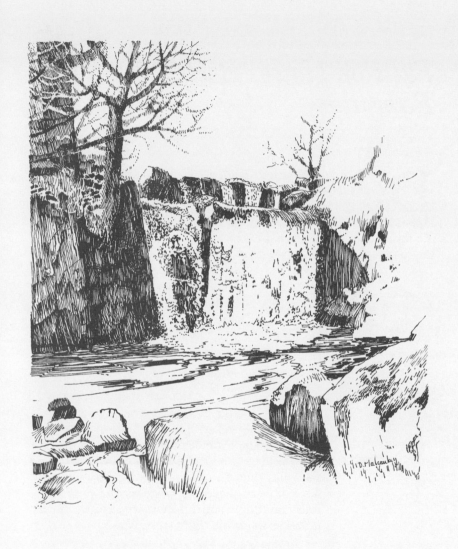

Falls on Howes Beck,
Bampton

Falls on Howes Beck, Bampton

Drive through Bampton Grange, heading west. Once across the bridge over the River Lowther turn left. After passing Greengate Chapel cross the sturdy old bridge over Haweswater Beck and leave the car on a largish tarmacked area on the immediate left. Adjacent to the bridge on the opposite side of the road — the north-west end of the bridge — is a stile that gives access to a footpath along an embankment, now laden with untrodden snow. To the right of the path flows the pretty beck edged with beech, ash, birch and alder, the latter laden with glowing-coloured catkins. Blue tit whisper and sing in the bare branches. A great spotted woodpecker flies out of one of the trees, its large white shoulder patches catching the eye. Jackdaw prod the bare ground where the snow has been scraped aside by hungry rams. A flock of wood pigeons fly overhead, a curlew calls hauntingly and a peewit repeats its name as it dashes in erratic flight upstream.

Follow a narrow track down the embankment and join an indistinct trod across the snowy pasture to a stile in the wire fence. Beyond, across more pasture, is another stile.

Rams and alder

Once over this, head for the gate onto the lane. Turn right and walk into Bampton. The lane is bordered with hazel loaded with catkins. A rook flies overhead managing a long, branched twig. It circles a huge Scots pine, the site of a large rookery, and then it settles on a nest. Stand on the bridge in the middle of the village and look upstream at the sparkling falls on the Howes Beck.

Continue on through the village and at the telephone box turn left, taking the narrow road up onto the fells. Make a short diversion from the fell road over the intervening rock-strewn fell on the left, quickly reaching the bank of the Howes and a series of tiny, dancing falls. Return to the road and walk on past Mill Crags Farm. When the road makes a hairpin bend to the right, keep straight on along a cart-track that climbs steeply into an icy wind sweeping over the snowy fells. Gorse bushes scatter the ground and the tiny yellow flowers are waxen where touched by frost.

Bear left when the track divides. Three splendid piebald ponies feed on grass beneath the gorse, the only snow-free vegetation to be seen. Fortunately the midday sun is warm and soon more grass will be exposed. From the highest part of this track over the Howes,

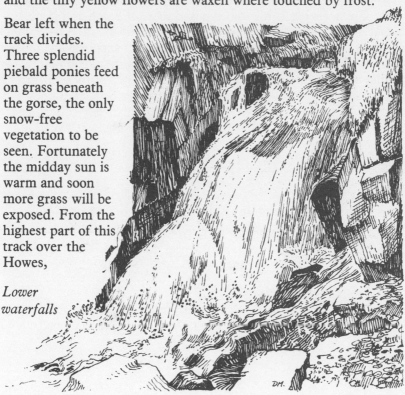

Lower waterfalls

the white slopes of Bampton Common are viewed. Pass through the gate that lies across the track. To the left a footbridge leads over the beck and a small dam has been built. Do not cross; keep to the track well up the slope above the beck, to a gate in the fell wall at the north-east corner of a small plantation. But the snow has gone from the higher pasture and here, in the full warmth of the sun and sheltered by a wall from the chill wind, is the place for a picnic.

Refreshed, continue along the plantation fence to a gate which leads to a track down through the trees to the lovely Howes Falls. Blackbirds sing and fly across the gaps between the trees. Snow falls from the branches as the warm sun makes it relinquish its hold on the highest twigs. A thick carpet of moss spangled with wood sorrel and foxglove leaves covers the ground, and beech mast, larch and pine cones litter the forest floor. A badger sett with newly dug holes lies below the exposed roots of beech and larch, and fresh droppings show that the occupants are about. The sound of falling water leads the walker to the edge of a small ravine down which the Howes rages. The water races around boulders before making a small drop onto a wide, smooth, flat bed of rock. From here it falls in a broad curtain of sparkling water beneath an oak almost overwhelmed by ivy. The steep sides are lush with fern and rush but the sloping fell above the ravine is mantled with snow.

Stone bridge of perfect symmetry.

The beck races on and then cascades over blackened rock. Droplets thrown into the air as the beck ricochets from rocky impediments sparkle in the bright, spring sunshine. Rock gardens on either side of the hurrying water are deep in dead leaves dusted with snow. The little plantation is a quiet paradise, a place to idle, to enjoy the birdsong, to observe the emergent vegetation and to view the lively falls. When you can drag yourself away from such welcome seclusion return to the gate and continue on. At the next smaller planting of trees a cart-track unites with the path beside the fence. Walk along this to Stanegarth Farm and pass through two farm gates to reach the bank of the beck beyond. The hurrying water is crossed by a tiny, hump-backed, stone bridge of perfect symmetry.

The journey back is through the farm once more and then along the cart-track rather than the little path that followed the fence, until Hullockholme Farm is reached. From here it is but a few steps to a lane beyond. Turn right and walk down into Bampton. Overhead a buzzard slowly wings across the pastures unperturbed by a mobbing crow. Ahead lie the Pennines, pink and white in the late afternoon sun.

O.S. Map NY502177
4 miles

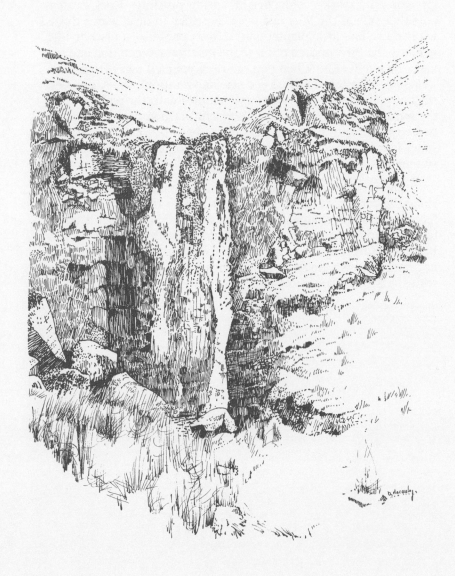

Waterfalls on Coegill Beck and Rush Gill, Dowthwaitehead, Ullswater

After several days of very warm April sun the verges of the lanes have burgeoned with flowers. Soft, delicate green leaves have emerged on several species of trees and the hedgerows, also adorned with spring foliage, resound to the songs of spring migrants. Now (contrariwise, as ever with the British weather) the temperature has dropped and overnight snow has covered the tops once more.

To avoid the exceedingly chill, north-east wind a waterfall sheltered deep in the fold of the hills seems a good choice. To reach the falls hidden in the foothills of Great Dodd, leave the A592, which runs along the shore of Ullswater, at the turn signposted Dockray. Turn left in front of the village inn and leave the car on the wide verge on the left just before the dwelling called Bank on the O.S. Map. Walk back downhill to a signposted gate. Beyond is the start of the footpath walk to Dowthwaitehead.

The track leads across a pasture full of ewes with twin lambs.

Bracken and celandine

The air is full of their bleatings and the deeper responses of their dams. The path passes through a deciduous wood high above the Aira Beck. Alder, rowan, silver birch, beech, sycamore and oak crowd the steep slope — the young foliage of each species creating a charming mingling of greens. Spurge and still-unrolled fern line the edge of the path and to the right, on a sunny bank, grows a huge patch of primroses. A willow warbler sings continuously from a low branch of a beech tree.

A footbridge crosses a tiny stream and milkmaid and celandine brighten its banks. The path continues through the small fields where violets, pink and mauve, grow close beside cow parsley, and wood sorrel and shepherd's purse thrive. Walk on past Crookwath and then follow the path as it crosses rougher pastures where the bubbling call of a curlew is heard. The track passes beneath a fine ash laden with large bunches of purple flowers contrasting sharply with the pale grey bark of the tree. When Dowthwaitehead is reached turn left and walk towards the bridge over the Aira. Leave the bridge by a small gate on the right and follow the wall for fifty yards then cross the little beck, the Coegill, at a suitable place.

Climb up beside the racing beck where violet, wood sorrel and rush flower. Beside a tiny fall, a clump of primroses catch the sunlight. Here, too, several pairs of meadow pipits prospect the tufts of fell grass for suitable nest sites and then fly upwards,

View of Dowthwaitehead.

trilling excitedly, before floating downwards with wings outspread. Cross the beck when a wire mesh fence is reached. Ahead lie some lovely falls dropping into a steep-sided, wooded ravine. To see these from the best vantage point continue up beside the fence, turning right at a trod that circumvents a steep crag. The very nimble may clamber down the slopes to a convenient knoll high above the falls.

Return to the trod and follow it until it crosses the Coegill, then continue along an easy trod beside the beck until the foot of another delightful fall is reached. Here the Coegill hurtles, white topped, over a ridged, steep-faced crag, falling in long tresses of water which rebound off each impeding ledge in a flurry of spray. Vivid green moss clothes the rock-face on either side of the fall. Celandine and fern flourish. Above the fall a large clump of juniper guards its descent. A sudden snow storm darkens the little hollow in the hills and then the sun comes out making the water sparkle and moss glow very green.

Walk back along the Coegill. From here tiny patches of the blue waters of Ullswater can be seen. Turn left, away from the beck, where it was crossed earlier. Follow a trod across the fell to Rush Gill, continuing along the top until a covenient place to cross the Rush Beck is reached. Turn right and keep to the path beside the beck and enjoy its noisy progress over its rock-strewn bed. Look behind at the tops of the Helvellyn range, covered with a deep layer of snow. Ahead the Pennines, too, are burdened with a white mantle and clouds

Upper waterfalls

47

tangle with their heights. A weir, now incomplete, fails to impede the water of the Rush before it tumbles in pretty cascades over large boulders and slides over smooth, squat rocks.

After another fifty yards leave the path and walk over to the edge of a small ravine and look back at a lovely waterfall. Here the Rush, after raging furiously down a narrow, imprisoning rock slide, leaps dramatically over a small precipice in one long, foaming jet into a deep, brown pool. On one side grows a willow in pale, blue-green leaf and on the other thrives a young sycamore, its buds large and pink but as yet unopened. Walk on beside the beck and pass through a gate to a grassy path between high walls. Here more sycamore grow but their buds have opened and small, yellow-green leaves are just beginning to show. Chaffinch sing and chase through the branches. Another gate gives access to a metalled track. Turn left and walk back towards Dockray along the narrow lane. To the left occasional glimpses of Blencathra are seen.

O.S. Map NY365205
 NY368208
5 miles

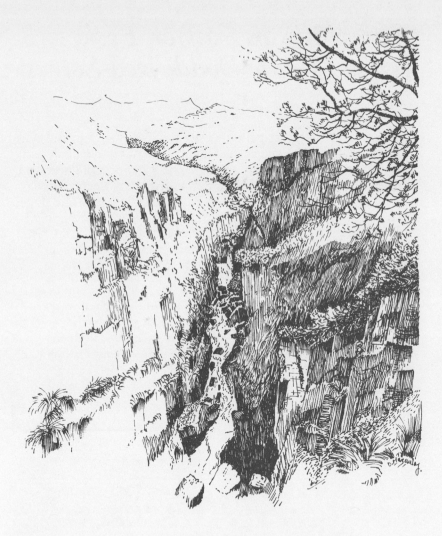

*Waterfalls on Caiston Beck,
below Middle Dodd, Red Screes*

Waterfalls on Caiston Beck, below Middle Dodd, Red Screes

Park in the large car park opposite the Kirkstone Inn and start the walk by the gate at the far end. Follow an indistinct path that runs north close to the drystone wall bordering the road through the pass. To the left Red Screes rises very steeply, with several stalwart climbers toiling up Kilnshaw Chimney. The slopes are a mass of scree. Worn, red tracks lead to the top and tumbled boulders litter the flatter ground at the base of the mountain. One of these boulders, called the Kirk Stone, gives the pass its name. Overhead wings a raven, calling quietly to its mate high above.

Continue along the trod, which passes behind a second car park lower down the pass. Across the road to the right a lively waterfall cascades down rocky steps to add its water to the Kirkstone Beck. This fall, always foam topped, has delighted the writer on her many trips through the pass when travelling south. Just below the waterfall the trod leads to the road and then within a yard or so a signpost directs the walker along a permissive path to Brothers Water. This tranquil stretch of water is a bright blue

Kirk Stone

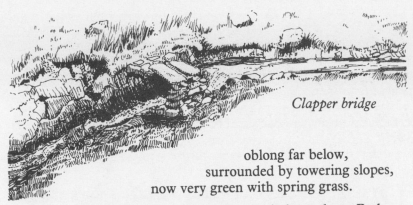

Clapper bridge

oblong far below,
surrounded by towering slopes,
now very green with spring grass.

Above to the left another beck drops down Red
Screes in graceful falls. These, when in spate, slash the slopes
with white foam. And high above lies North-East Comb, red and
secretive. The path lies well above the road and between the two
flows the joyous Kirkstone Beck, hidden from travellers on the
road but a delight to the walker. Bilberry grows in profusion along
the walls of the rocky ravine through which the beck hurries to
race beneath a picturesque clapper bridge. Small feeder becks add
to the Kirkstone, having gathered their water from the steep slopes
on the other side of the road so that the main beck becomes a wide
mountain stream with pretty falls beneath willow, ash, hawthorn
and rowan, all in young leaf.

The path is generally easy to walk along. In some places it is
rocky but there is much springy turf. Parsley fern brightens the
boulders on either side but as yet many fronds are still delicately
rolled. Large black beetles cross the track wandering between
blades of grass and the bright red leaves of low-growing bilberry.
Continue along the path as it swings away towards Caiston Glen,
passing between hawthorn where chaffinch and yellowhammer
sing their spring songs. Once past the trees, leave the path and
swing left across the pastures to the Caiston Beck. Cross the beck
on convenient boulders and join the path that runs up the glen,
turning left beyond the fell wall. This is another good path which
now, in late April, is bordered with many celandine and violet.

The climb through the glen, close to the lively beck, is a great
pleasure. There are pretty falls for much of the walk, one beneath a
leafless ash, and another below willow and rowan in delicate leaf.

There is a long, long, rock slide down which the water chatters and dances. Wood sorrel is in flower among the boulders and juniper hugs the top of a small ravine. Meadow pipits abound, chasing each other from rock to rock and then fluttering upwards trilling ecstatically. Wheatears, resplendent in spring plumage, fly upwards singing less musically than the pipits. Then they too hurtle downwards gossiping, churring, scolding as they do so, caught up in spring rituals and encouraged by the warmth in the sunlit glen. To all this joyous birdsong is added the strong, warbling melody of a small wren, busily inspecting rock crevices close to the water.

To the left, the slopes of Middle Dodd are bathed in brilliant sunshine, making a splendid backdrop to the foaming Caiston. After half a mile up through the glen the slopes become less steep and the pastures around the beck flatten out. Cross over towards the left, stepping over the many small tributaries, to where the Caiston drops down from the steep north-west slopes of Red Screes. Here in a deep, sunless ravine the beck rages downwards in two graceful falls beneath rowan and ash still in bud. The foaming, white-topped water passes between banks of bilberry, moss and fern. A small side stream coming in from the right plummets downwards splashing the emerging vegetation with sparkling droplets of water. An angry ring ousel leaves the lonely ravine and heads off towards Hart Crag.

This is an elegant waterfall hidden in a lonely cleft away from the path that leads to the Scandale Pass. It is easy to miss its secluded glory and such an omission would be a loss.

O.S. Map NY393097
6 miles

Pretty falls for much of the walk.

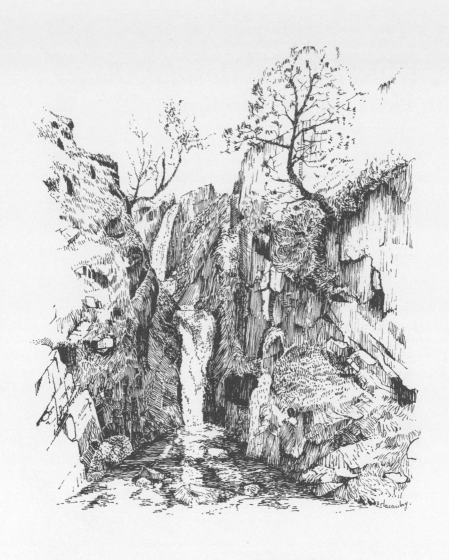

*Waterfalls on Mosedale Beck,
Matterdale Common*

Waterfalls on Mosedale Beck, Matterdale Common

Take the turning at Dockray for Dowthwaitehead. Where the road swings sharply to the left, and New Road sharply to the right, a large grassy mound is used as a small car park. Just beyond the mound is a kissing gate giving access to the old coach-road. Along this ancient route the waterfalls on Mosedale Beck are reached.

In late April the lanes leading to Dockray are bordered with spring flowers. Ramson, pink campion, Jack-by-the-hedge, cow parsley, wild arum, wood anemone, primrose and violet compete for space and light. Above, the hedgerows are white with blackthorn and bird cherry. Cottage gardens rival the lanes with a brilliant array of tulip, narcissus and flowering cherry. Where else could be as glorious as the Lake District at this time of the year?

Follow the old track as it skirts the edge of a plantation of young fir. Robin and willow warbler serenade the sun and milkmaid thrives in the damp area beside the forest fence. Sheep graze and lambs gambol on the fell to the left. Ahead lies Blencathra, dark and forbidding as the sun disappears, obscured by sombre, lowering clouds.

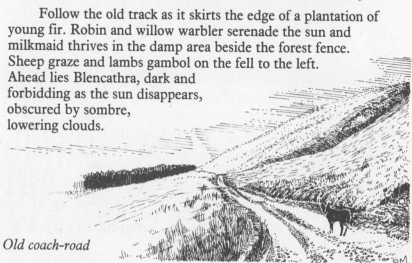

Old coach-road

Beyond the trees, open fell stretches away on both sides of the track. Meadow pipits soar upwards, five or six at a time, singing ecstatically. A skylark starts to carol after rising a few feet and then continues until it is a tiny speck in the sky. If Groove Beck is not in spate cross by the ford but there is a narrow footbridge just before the ford if you wish to remain dryshod. The side of the track is well drained and water crowfoot flowers in the water of the ditch. After half a mile another plantation is reached, this one contains mature spruce which casts more shade over the track.

Then all trees are left behind and the old coach-road swings out into the open fell once more. Away to the right the peat mosses seem to stretch to the foot of Blencathra. To the walker the mosses appear bleak and desolate but they greatly delight meadow pipit and wheatear. A curlew flies over the tussocks, a large, heavy bird with white back-parts catching the thin sunlight, its haunting cry silent as it approaches its nest. Tiny streams supporting a glowing crop of golden saxifrage run beneath the track which winds on ahead always following the higher ground. In the quietness and solitude one can imagine a coach, full of weary travellers, negotiating the dreary moss, each limb taut waiting for the next jolt. How did they survive wet journeys, misty journeys or snowy ones?

In one place the track is covered with pigeon feathers, the work of a peregrine.

Curlew and cotton grass

High above Wolf Crags the raptor flies, flapping its long, thin wings then holding them steady as it glides forward. It passes overhead, black against the sky, and as it drops down to the lower slopes of the crags its grey back and yellow-white underparts are seen.

Walk on past Barbaryrigg Fold and then down the sloping track to Mother Sike, a narrow, deepish beck cutting through the peat, full of broad-leaved pondweed. Think of the horses pulling the coach as you ascend the slope beyond. Follow the track as it leads downhill to Mariel Bridge over the Mosedale Beck. Turn left before the bridge and climb under the fence, walking uphill along the edge of the gurgling water. Here cotton grass, scurvy grass, violet and celandine spangle the bleached fell grass. Where willow and rowan crowd the bank the beck drops in a pretty cascade over moss-covered rocks edged with bright green grass. The foliage of the trees is young and pale green, allowing the sun to slant through the leaves to the foaming, sparkling water below. Above, on the bleak slopes below Mart Crag, two fell ponies feed undisturbed by the walker and her dog.

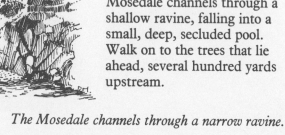

Continue beside the hurrying water to the next rowan. This one is laden with flower buds. They are still tightly closed, but the young leaves are dense enough almost to hide the twiggy nest of a crow. Below are more falls where the Mosedale channels through a shallow ravine, falling into a small, deep, secluded pool. Walk on to the trees that lie ahead, several hundred yards upstream.

The Mosedale channels through a narrow ravine.

The Mosedale, after flowing sedately across the fell between Clough Head and Matterdale Common, now rages between two confining boulders before it drops in a foaming jet into a small, narrow canyon. It drops into a boiling pool and then it races in a series of tiny cascades falling over stepped rocks into a wide shallow. Rowan and willow, in delicate foliage, lean over the lonely hollow. Large mats of wood anemone, primrose and violet, delight a host of bees. Bilberry, carpets of moss, and heather clothe the sides of the cleft. Parsley fern, polypody and wood sorrel fill the crevices of the surrounding boulders. A grey wagtail settles on a boulder and then sets off down the beck disturbed, for once, in this lovely, lush haven. The haven is the reward for the long walk over the fells still partly held in the grip of winter.

O.S. Map NY347224
6 miles

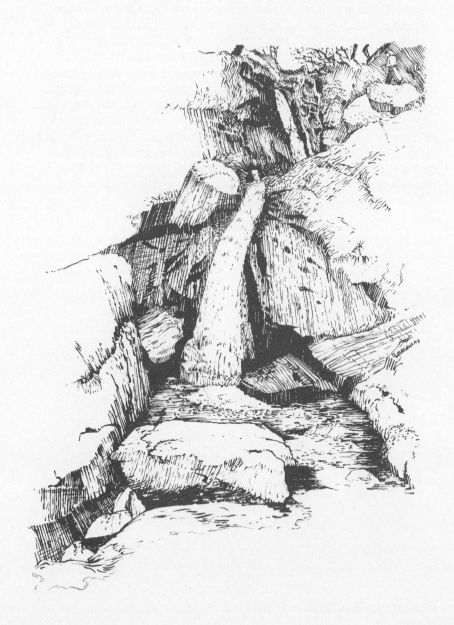

Dove Falls, Dovedale, Brothers Water

Dovedale lies to the north of the Kirkstone Pass. It is enfolded by Gill Crag and Black Crag on one side and High Hartsop Dodd on the other. A footpath passes through the dale to the waterfalls and then journeys on up to Dove Crag at the head of the valley.

There is good parking in a marked area by Cow Bridge at the north end of Brothers Water. Here ash, sycamore and hawthorn, all in pale-green leaf in the middle of May, shade the beck and the vehicles.

The bridlepath is reached by a gate to the left, on the far side of the bridge, and runs beside the small lake. The woodland floor, on both sides of the path, is covered with violet, primrose, wood sorrel and young bracken. In the trees, willow warbler, wren, chaffinch and whitethroat serenade the sun.

Violet

Soon the path rises above the water and passes among elm and oak, with wild arum in flower beneath. Through the trees fly a pair of restless long-tailed tits, busily seeking food for their young. Below, the water is blue and sparkling where it catches the sunlight.

A gentle breeze stirs the reeds lining the shallows. Where the ripples reach the shore, a dipper hurries to meet the waves and dives repeatedly below the surface. It travels twenty yards from the shore until it can no longer reach the bottom, then it turns and continues in the same fashion until it reaches the shingle shore once more. Here it takes up its familiar stance on a rock, bobbing up and down spasmodically. Coot and mallard float idly by.

Beyond Brothers Water lie wide pastures supporting large numbers of sheep and lambs. To the right of the path the fell slopes are covered with hawthorn and blackthorn, the latter a cloud of white blossom. Skylark rise, quivering with song and then, from a great height, make a rapid, silent descent.

Just before Hartsop Hall a male redstart inquisitively inspects the progress of the walker. Here too, a great spotted woodpecker drums its bill on an old trunk, the vibrations rattling loud and clear through the valley.

The farm at Hartsop Hall seems full of puppies, lambs and Galloway calves. The calves stagger unsteadily to their feet and quickly move close to their mothers. Once the walker is through the gate the fell opens up but it is still patterned with single larch

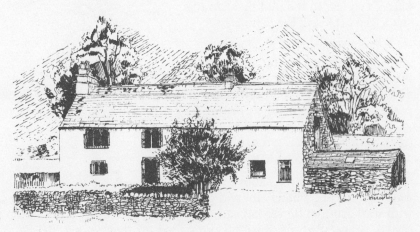

Hartsop Hall

and birch. Tree pipits abound, ascending from the tip of a favourite tree, trilling as they rise, then descending with wings outspread —like miniature parachutes — still singing, to return to the same perch.

The path winds deeper into Dovedale. By a shepherd's hut a wheatear "chack, chacks" and fans out its tail, showing its white feathers, all black-tipped. It flies noisily and in a distressed way, trying to distract intruders from its nest.

Then the path comes close to Hartsop Beck. There are fewer trees. Meadow pipit replace tree pipit and continually make sorties into the air.

A footbridge among elder, rowan and silver birch crosses the beck. To the west lies Hogget Gill, dark and forbidding. Once over the bridge the path keeps close to the beck, climbing all the time, until Dove Falls are reached.

Hartsop Beck rises from the slopes of Hart and Dove Crags. It flows through the treeless slopes until it reaches the fell wall and from here tumbles joyfully over rocks and ledges into the tree-clad gill. It pauses and then runs slowly, making a large loop before it passes under a clapper bridge shaded by alder. Just below the bridge it is joined by a tributary and then races around a fallen birch and tangles with a hawthorn before hurrying past wood sorrel, primrose and violet.

It passes under a clapper bridge shaded by alder.

It then slides beneath birch down a narrow defile to leap exultantly down its first fall in a wide fan of white water into a small but deep, dark green pool.

It then deflects to the right, dividing into three long, foam-topped streams of water and falls once more into a pool where it pauses before rushing between a narrow gap in the confining sides of the gill. Another smooth slipway takes the beck onwards to fall headlong over huge boulders that make the water 'boil'. After being joined by a small side stream the beck falls into a clear, blue pool whose floor is covered with large, coloured stones and whose banks are lined with liverwort.

The Hartsop flows on in a series of tiny falls that chatter under birch and hazel, past ash still in bud. Close by, bilberry is in full leaf and bracken throws up its first curled fronds. A cuckoo calls regularly from nearby trees and a large red-headed merganser makes regular flights from the lake to the fell. Perhaps she is feeding a brood hidden high on Hartsop Beck where it rises on Dove Crag.

O.S. Map NY387116
4 miles

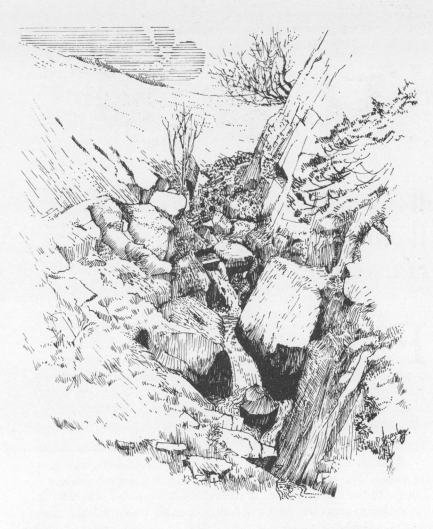

Waterfall on Woundale Beck,
below Hart Crag,
Woundale

Waterfall on Woundale Beck, below Hart Crag, Woundale

From the gate at the start of the walk Woundale appears rocky and desolate. The valley slopes upwards, almost imperceptibly, to the skirts of Hart Crag. Ancient, lichen-encrusted drystone walls march across the dale and up the enfolding slopes. Sheep with their lambs seem to be the only living things that have escaped the deep sleep of winter. Yet there are many gems hidden in this tiny valley, between the Trout Beck and the road that runs up to the Kirkstone Pass.

Park in a lay-by on the A592 just above the gate and stile into the valley. This lay-by is 1.4 miles above the junction of Holbeck Lane with the A592. There are several lay-bys but this one enables the walker to cross the road and leave the noisy traffic behind in the shortest possible time.

The track beyond the gate keeps close to a wall and leads to another gate. Follow the track until it crosses the Woundale Beck by large slabs of rough-hewn slate. Walk through a sheepfold to the other side of the beck to see the lovely slate bridge sideways on. Four pillars of drystone support the slabs, similar to the slate bridge

found over the Trout in the next valley. By the footbridge the banks of the beck are aglow with golden saxifrage and on the wall a pair of pied wagtails pause as they deliver caterpillars to youngsters in a crevice.

Continue along the track beside the beck. The damp pastures on either side support celandine, kingcup and milkmaid. The latter attracts numerous small white butterflies with delicately-veined wings. The air resounds to the continual songs of dozens of meadow pipits, many of which rise trilling into the warm May air. Others stand aggressively on nearby boulders, taking umbrage at human or wheatear intrusions alike. Violets, pale mauve through to white, grow in the drier pastures by the beck, but in the hollows, splashed by the hurrying water, large-petalled, deep-purple flowers thrive.

Now the path begins to climb. On a steep slope to the left of the Woundale Beck stands a ruined hut. Most of the roof slates have disappeared but the fireplace and window frames remain intact, as well as timbers that may have supported an upper floor. On the high ground above the hut a few rowan crowd the edge of a small tributary stream. Here a crow wings into a tree with a large trophy in its beak.

Below the hut in a rocky canyon the beck makes a foaming fall. Here on the spray-wet sphagnum that edges the path grow the dainty, starry saxifrage, tormentil and the red-tipped leaves of sundew. Wood sorrel and liverwort luxuriate in damper crevices and the leaves of butterwort, star-shaped rosettes, cover the very wet areas. Above the little canyon, walk beside the Woundale as it descends gently in tiny cascades flowing over smooth rocks into small deep pools. Then the bottom of another ravine is reached, and another reward of the walk. The beck races through the confining rock walls in a series of small jets, the first

A ruined hut

slewing to the right. After racing around impeding boulders it slews again to the right in another foaming jet and then hurries through a tiny cleft to fall in two jets on either side of a hindering boulder.

Top of main falls

It is easy to clamber along the top of the ravine and look down into this lush, secluded cleft. Above the falls the beck hurries along another rock slide into a swirling pool. At the top of the slide, rowan and a holly shadow the beck as it makes its first cascade into the canyon. Just before its descent it curves round a large, grassy island that divides the beck in two, tumbling between a narrow gap in the huge rocks below the rowan. Large clumps of bilberry covered with soft, pink flowers clasp the sides of the little canyon. Alpine lady's mantle, parsley fern and mountain fern grow in rock gardens. Large patches of wood sorrel and wood anemone, both with abundant flowers, lighten shady corners. Tiny rowan and sapling rowan, covered with delicate leaves, grow here too.

Continue on beside the beck, now a narrow ribbon of water cutting deeply through the peaty pasture. In a few hundred yards the beck is lost to sight beneath large patches of red-topped sphagnum and then it is no more. In this quiet hollow, under Hart Crag, the Woundale Beck is spawned.

Even now the vale has not given up all its treasures; from this birth place of the beck the walker gains a magnificent view of

Windermere and Esthwaite Water and their surrounding wooded slopes. And in the distance small fingers of sea sparkle in the afternoon sun.

Overhead a noisy gathering of ravens attracts the attention. In the binoculars two raptors are seen to be the cause of the excitement. Slowly these two large birds, with pinions splayed, soar upwards in large circles until both are lost to sight. Perhaps these are the pair of golden eagles, reported by the local press to be nesting in Lakeland, and which have left their precious youngster for a short time to enjoy the warm sun. If they are, Woundale cannot claim them as its own for the ascending spirals of the pair encompass most of north-east Lakeland.

O.S. Map NY410084
3 miles

Force Jump, Kentmere

On an uncharacteristically cold, windy day in May, the waterfalls high up on the fells are unattainable. Winds may gust up to 70-80 mph on Nan Bield Pass at the head of Kentmere, so a sheltered walk along walled lanes and among the burgeoning trees is not only a pleasure but the only possibility.

A pleasant way to approach Force Jump is to park on the verge in High Lane where a footpath from Kentmere to Longsleddale is signposted and walk from there. A few yards further on along High Lane take another signposted track for Mardale. Here oak, sycamore and beech are in young leaf and flower. Many leaves and flowers have been torn off by the high wind and now litter the path. Ash trees line the track beside a pretty beck and their buds are tightly closed. Rooks are busy around their nests and several birds sit steadily on the topmost branches in spite of the buffeting wind. The pastures, now very green, are full of sheep with sturdy lambs.

Leave this path at the next farmhouse and turn left before the signposted 'Bridleway'.

Rooks are busy

This track arcs across open pasture spangled with large numbers of marsh marigold. Young starlings fly overhead and then settle close to the sheep and begin pecking the ground. The track joins Low Lane, a wide, grassy path between walls and one which runs parallel, at this point, with High Lane. Here the fearsome wind is kept back and there is time to dawdle and enjoy the colourful verges.

Celandine, wood sorrel, milkmaid and violet flourish here, and leaning over the walls are hazel and hawthorn, their pale green leaves tossed hither and thither. Further along the track are greater stitchwort, wood anemone and bluebell. Pass through a gap in the wall on the right and walk into a little wood under hazel, elm and ash. Here, in the lea of the sloping ground and the other trees, the ash buds are open and pale green spears of unrolled leaves thrust upwards.

A little path passes among more violet, wood sorrel, bluebell, wild cress, celandine and primrose to the edge of the River Kent. The water of the Kent races white topped and purposefully around a small, grassy island supporting rowan and oak just in leaf. Here too the waterfall starts its spectacular plunge through a rocky canyon and a dipper, dark backed and white bibbed, flies upstream. It keeps just above the spray that fills the air above every rock projecting through the surging water.

Sheep and lambs and stitchwort

70

Return to the lane, continuing between the walls, until it is joined by High Lane. A few steps further along the lane brings the walker to a gate on the right which gives access to a field sloping down to alders lining the bank of the river, and to the bottom of the lovely, tempestuous Force Jump waterfall.

At the top of the Force, seen briefly from the wood, a wide fall of water topples over the precipitous edge, joined by two side falls, which together drop onto a ledge that sends spray upwards into the air and a foaming torrent downwards. This broad band of white water falls into a black pool and then tumbles once more in silvery cascades onto rocks below. Then the River Kent, after lightening the dark, imprisoning gorge through which it has streamed, widens out and flows sedately towards the village of Kentmere.

Eventually the lovely fall must be left. Return to the gate and turn left, back along High Lane. Now the walls are seven feet high and once again the angry wind is kept at bay. A heron, seen through a gateway in the wall, finds no difficulty with the air currents and lands easily in a field. In the same field black ponies, with long tails touching the ground, graze, they too unconcerned by the weather. Pause here and look back along the delightful Kentmere valley.

Today, because of the wind, visitors are few and the valley is peaceful. The walker should not leave without viewing Kentmere Hall. To do this, park at the church and then take the farm track opposite that leads to this 14th century pele tower, built for defence against Scottish marauders. It is not open to the public. Adjoining Kentmere Hall is a 16th century farmhouse.

O.S. Map NY461044
2 miles

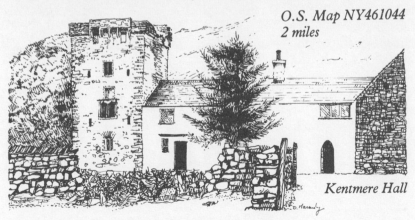

Kentmere Hall

Waterfalls in Deepdale, near Ullswater

Three large falls of water form Deepdale Beck. The first drops from Link Cove and races through a steep, narrow gully, tree-lined and flower bedecked. The second, the Forces, a series of waterfalls, cascade over the almost perpendicular slopes of Greenhow End, the sentinel-like mass at the head of Deepdale. And the third, the main object of the walk, lie to the north of the Forces and slip over rocky shelves.

The water that sparkles so is gathered from craggy slopes below Deepdale Hause. Several becks drain the desolate hollow below the crags and come together to drop in a long jet into a pool, only to drop again in another jet. Then the water cascades over scattered boulders to flow down a narrow cleft lined in late May with rowan in flower, ash and silver birch. The banks of the beck are covered with young fern, bilberry, rose root and a deep-pink cranesbill.

Then the beck continues in long streams of foam-topped water, each fall

The beck continues in long streams of foam-topped water.

73

catching the sun in spite of being hidden deep beneath the young foliage of the trees. The water flows on until it reaches smooth ledges of rock over which it cascades, dividing into many white tresses of water. Unlike the falls above, these cascades can be seen from a long way down Deepdale. Towering over the crags and the streaming water is the north-east flank of Fairfield, dark and solid and seen at its most impressive.

Once down the steep mountain slopes, water from the Forces and the becks joins to meander through Mossydale between glacial moraine — large hummocks clad with new grass, milkwort, bedstraw and wood sorrel. Here wheatear, when disturbed, take cover in holes under boulders. These holes are lined with grass and extend a long way from the entrance before the nest is reached. Large beetles, some with a bright, petrol-blue sheen and others a warm bronze, enjoy the sun.

Deepdale Beck moves quickly over its rocky bed on its way to join the Goldrill Beck. The track through the valley bottom keeps close to the water and is easy to walk along. The pasture on either side is very wet, the various species of moss holding a lot of water. Starry saxifrage with white petals and pink stamens and water forget-me-not grow in pools stained with peat. Bog stitchwort, with tiny star-like flowers, mingle with the moss. Sundew, their leaves red-tipped, compete with the moss and are still not in flower — unlike the common butterwort, which has produced one lovely mauve flower to each rosette of leaves. Lousewort is in flower, too. Where the turf is drier, thyme is opening its tiny purple flowers creating colourful, scented mats. Bedstraw, tormentil and marsh speedwell seem to blossom everywhere. Here is utter peace, no lake to encourage noisy tourists, no road, just warm sun and silence.

Butterwort

To reach the head of Deepdale, park in a small area by the phone booth, south of Deepdale Bridge. Cross the bridge and immediately take the walled bridlepath that bears off, straight and narrow, to the left. The stones of the wall are covered with patches of yellow lichen. A cuckoo calls from Deepdale Park. A small tortoiseshell, the first of the summer, flits ahead. Common mallow brightens the verge with its pink flowers.

After passing through a gate to the left, continue past Deepdale Hall and Wall End. Trees shade the path. Hawthorn trees, heavily laden with blossom, are scattered over the lower slopes of the fells. Bright green parsley fern fills crannies beneath rocks and a pair of redstarts stay close together as they move through hawthorn by the path.

Bridge over Deepdale Beck

Just after Wall End the track leads off into the intriguing depths of Deepdale. Here Coldcove Beck, which rises upon St. Sunday Crag, enjoys its leafy gill, hastening beneath a clapper bridge to reach Deepdale Beck. A grassy path leads off to the right, keeping close to the cheery beck. Follow it, climbing gently, past kingcup and young bracken. The cascades lie ahead. Sit here and sunbathe and listen to the meadow pipit and the gurgling water. The beck slides over a steep drop, the water spreading out into a white curtain. Rowan, birch and hawthorn lean over the beck but the young leaves allow the sunbeams to pass, dappling the water and grass alike; a delectable corner of quiet, secluded Deepdale.

O.S. Map NY368125
6 miles

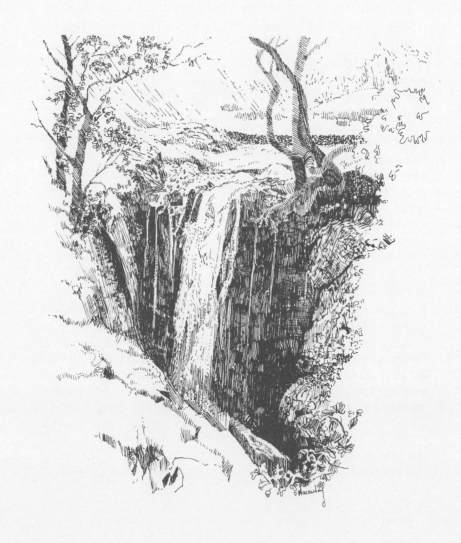

Waterfalls on Blea Water Beck and Small Water Beck, Haweswater

In spite of the bleached shoreline, the road beside Haweswater, with the wonderfully dramatic mountains ahead, is a delight to drive along at the end of May. Spring comes later to this quiet corner of Lakeland and the grassy verges are still bright with primrose. The many ash trees that line the shore-side of the road have yet to release their young leaves from dark buds. From one of these trees a brightly-coloured redstart flies across the road to the rocky fell slope opposite. A jay, with its stubby shape and laboured flight, makes the same trip. Below on the shore, four barnacle geese with eighteen goslings between then move in and out of the water. The goslings keep up a continual piping and scurry towards an adult or skate over the water when left behind.

There is a small parking area at the head of the lake and several large verges on the roadside. To reach the waterfalls, on the way to Small Water Tarn, pass through the gate at the road end and then walk straight ahead, following the sign to Kentmere on the triple-armed signpost.

Tormentil and bedstraw

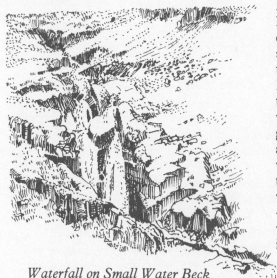

Waterfall on Small Water Beck

A willow warbler sings loudly from the nearby conifers and the piping of sandpiper comes from the head of the lake. Follow the well defined track over the open fell where tormentil grows in great abundance. Pause at the first gate in the wall that crosses the fell to look at the old Roman way, high up on the right — today as busy as it was when first used by the invaders.

The track passes between glacial moraine covered with tormentil and bedstraw. Wheatear abound, and meadow pipit, those ballet dancers of the air, flutter upwards and then descend with wings outspread, delicately turning and balancing as they land with perfect precision. Below to the right lies the first waterfall. To reach it cross the fell and the Small Water Beck. Blea Water Beck lies a few yards further on. If the beck is not too exuberant enter the steep-sided ravine and clamber over the boulders to the foot of the fall. The beck tumbles over a smooth ledge to drop many feet into the dark hollow. Jutting boulders project into the wide curtain of water and send spray into the ravine. The sun, still high overhead, catches the droplets, making them sparkle, brightening this shadowed gill. Much spray falls on a clump of wood anemone and perhaps this continual moisture accounts for their very large flower heads. The rock sides of the gill are covered with moss, lady's mantle still in bud, heather and wood sage in green leaf, mountain fern and hard fern, liverwort, honeysuckle and violet in flower. Hawthorn, willow and rowan grow in the gill and several silver birch guard the top of the fall. A mass of feathers covers boulders in and beside the beck, the tell-tale work of a sparrowhawk.

Leave the lush isolation, returning to the path, and continue to a gate in the next wall. Bright green-leaved parsley fern fills many a crevice below the huge boulders littering the fell. Flowers are just appearing on the hawthorn scattered over the slopes. From one, a tree pipit ascends and descends, frantically declaring his suit and his territory. From here can be heard the common gull and lesser black-backed gull that crowd the islands at the head of the lake.

Climb on up the path until it comes close beside Small Water Beck. A few yards further on and another delightful fall lies ahead. The beck foams down a rocky precipice, sending out clouds of spray. The water races on and then cascades beneath rowan and birch, both clad in soft green leaf. Adorning the banks are large mats of bilberry covered with delicate, pink flowers and more lady's mantle. High on the crags, to the left of the path, a pair of ravens bring food to their brood, greeted each time they return with a noisy screeching.

Continue along the path, crossing a small feeder beck bridged by two large slabs of slate. Rocks entirely of quartz and veins of quartz in other boulders sparkle in the bright sun. Another lively fall fills the air with the noise of rushing water as the Small Water Beck descends through a steeply sloping canyon where more bilberry is in pretty pink flower and lady's mantle is still in bud. Another steep pull up the path and Small Water Tarn lies ahead. The immediate slopes are grass covered and just made for collapsing onto after the arduous climb in the warm sun.

Small Water Tarn

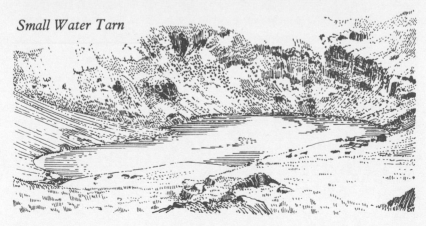

Beyond this lovely sheet of water, covered with gentle ripples as a soft breeze catches its surface, lie the steep slopes up to Nan Bield Pass. Today energetic climbers toil up the pass, they walk hunched under their packs across the top of Harter Fell and file along the top of Long Stile and Rough Crag.

When you can bear to leave this delightful tarn cross the beck by the stepping stones and climb to the top of the small crags ahead. Enjoy the splendid view of the tarn close by and of Haweswater shimmering in the mid-afternoon sun far below.

O.S. Map NY463106
 NY461104
3 miles

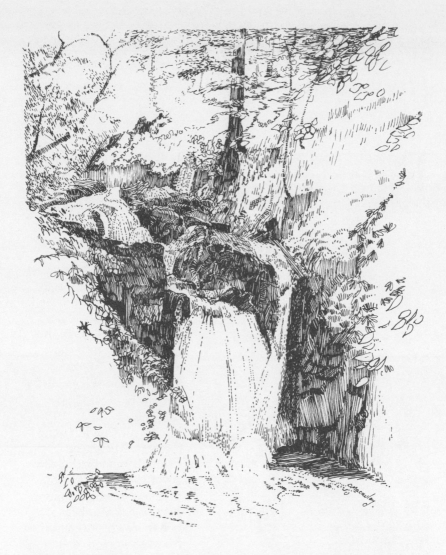

Waterfalls on Rydal Beck and High Fall, Rydal

Waterfalls on Rydal Beck and High Fall, Rydal

Park in the lane by St. Mary's Church, Rydal. Walk uphill, passing Rydal Mount on the left and the entrance to Rydal Hall on the right. On the first day of June rhododendron in the gardens of these two houses and the nearby cottages rivet the eye with their riotous colours. Continue straight ahead when the concreted road becomes a cart-track and turn right through a gap in the wall. This gap lies just before a gate across the track that continues on into the valley of the Rydal.

Beyond the gap a narrow path winds its way through lush undergrowth and young fir trees. Masses of bluebell and shirtbutton cover the ground where the path moves in among mature oak and beech. Climb down the soundly-restored steps to just above the racing Rydal and an excellent view of a delightful waterfall. Stand by the gate to the

Natural bridge above High Fall

bridge and notice the rich variety of ferns, honeysuckle, wood sorrel and rhododendron that thrive in this moisture-laden hollow where the leaf canopy is not yet too dense to allow the sun to penetrate and promote growth.

After crossing the bridge turn left and follow a path that runs beside the dancing water. More steps bring the walker to the edge of a deep ravine and the cause of the tremendous roar of water. Turn left, walking down several more steps that lead to a natural viewing platform. Ahead lies the magnificent High Fall just below Birk Hagg. At the top of the fall the Rydal is channelled into a narrow gap between two rock walls. Into this gap has fallen a huge boulder forming a natural bridge. The obstruction and the confining sides turn the Rydal into a raging torrent as it drops over a narrow ledge. It falls in a wall of white water into a very deep, dark pool far below. The surging water hurries through the pool, divides and then cascades into another pool. Beyond, a series of rapids take the beck towards the bridge crossed earlier.

This splendid fall is hidden deep in woodland. Elm, beech, ash, sycamore, oak and rhododendron, the latter covered with pink blossoms, shade the water. Beneath the trees grow wood sorrel, rush and many delicate ferns. Last year's leaves still litter the ground. A marsh tit calls harshly, revealing its position as it hangs upside down by one leg searching for insects. A coal tit comes so close that it is possible to see a small caterpillar wriggling in its beak. A pair of dippers fly from close to the main fall, downstream, returning regularly to a hole beside the falling water. Their flight is fast, direct and just above the beck and they are quite unworried by humans so close to their nest.

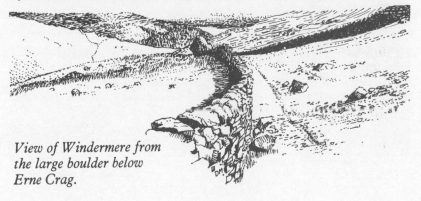

View of Windermere from the large boulder below Erne Crag.

Walk on along the path, bordered with bluebell, as it climbs beside the falling water until a drystone bridge is reached. Above the bridge is a weir and the water descends from this in a plume of white foam. Cross the bridge and walk over turf spangled with tormentil, bedstraw and bluebell. A gate ahead gives access to a cart-track that leads into the valley of the Rydal, which is enclosed by the mountains that form the Fairfield Horseshoe. The second waterfall of this walk lies just below Dalehead Close.

The track passes a small larch plantation, where tree pipit regularly ascend into the warm summer air. It passes Buckstones Jump waterfall, visited in Book One of this series. Look back to Windermere, with Ambleside at its head. Swallows and swifts scream overhead as they feast on the myriad of flies brought out by the warm sun. Continue along the track, which follows a sturdy drystone wall much used by wheatear, meadow pipit and pied wagtail. Buttercup border the track and tormentil grow among the tough fell grass. Where small streams hurry down the hillside to join the main beck, lousewort and butterwort thrive, the latter now bearing delicate purple flowers.

The track ends beneath Erne Crag on the left and a huge boulder on the right. Walk on, beside the wall, following trods. At the bottom of a steep slope stands a gate which gives access to the pasture that flanks the Rydal. Turn left at the gate and follow a well-defined trod. Notice the interesting stone sheepfold surrounded by two arms of the now gentle Rydal Beck. Once past the sheepfold strike out right

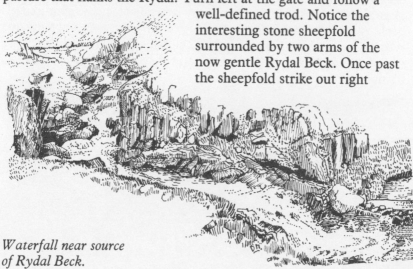

Waterfall near source of Rydal Beck.

across the pasture to the waterfall in a small ravine. Here under one small rowan and a stunted holly the young beck cascades and drops in tiny, white-topped falls as it swirls round larger boulders. Then, where the ravine makes a sharp twist to the right, the beck tumbles in a great hurry over a wide ledged rock, making the water foam as it bounces over each ridge.

This is a pretty waterfall, in great contrast to the majestic High Fall. Here the beck flows through a shallow ravine with little to obscure its charm. Few trees adorn its banks and tiny plants thrive only in crannies beneath the rocks. Bleak fells sweep upwards to the heights and wheatear and meadow pipit flit quietly about the rocks. Here is peace, solitude and a place to think.

O.S. Map NY366068
 NY362097
5 miles

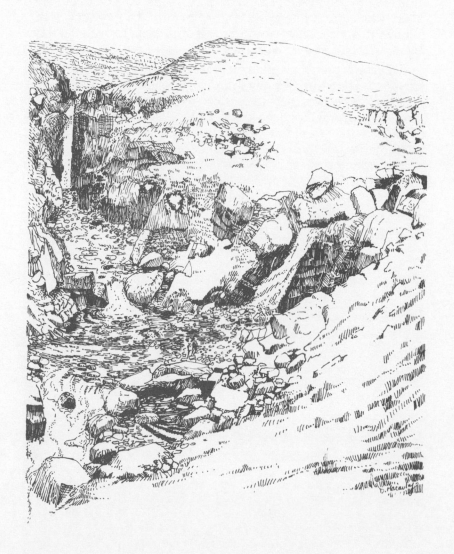

Waterfalls at the confluence of Wren Gill and River Sprint, Longsleddale

F our miles from Kendal, along the road to Shap, is the sign for Longsleddale. There are few passing-places in the lane that runs through this lovely, quiet valley and lush verges encroaching over the tarmac make it appear exceedingly narrow in some parts. Only the passengers can really enjoy this beautiful drive.

In June the hedgerow vegetation is a riot of colour, as only Cumbrian lanes can be. Wood cranesbill, bloody cranesbill, blinks, red campion, bistort and herb robert provide the reds and pinks; the white of ramsons, cow parsley, and sweet cecily accentuate the blue of viper's bugloss, bugle and bluebell; and dandelion, buttercup and (in the wetter areas), touch-me-nots, add a bright splash of yellow.

Three miles along the lane, below Capplebarrow lie the old school and the church, both built in 1863, and framed by the austere fells at the head of the valley.

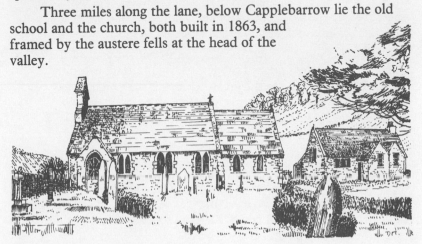

The church and school in the valley

The River Sprint, never far from the road, chatters through the valley. At Stockdale Bridge the road and river come very close and here an avian drama occurs. A young sandpiper hurries from the river across the road, bringing the car to a halt. The agitated parents hurry after it, and then fly onto separate fencing posts and begin to call frenziedly. Only when the fledgeling seems safe in the grass verge can the car move on, and give the distressed female a chance to coax her wayward offspring back to the safety of the water's edge.

The tarmacked road ends at Sadgill and there is space for cars by the graceful bridge that spans the river. Here the valley bottom is several fields wide and in these cows graze and chickens and geese peck among the lush, green grass. Close to the beck one of the pastures is a cloud of yellow, where marsh marigold grow in profusion.

In the humid June air many insects are on the wing, much to the delight of dozens of house martins. These blue-black birds, with their white rumps and bellies, wheel and dive enjoying a plenteous feast.

Stretching ahead from the bridge is the quarry road leading to the waterfalls and keeping beside the snaking Sprint, sparkling in the sunshine of a summer's day. At first the way lies along the valley bottom and though the road begins to climb it does so imperceptibly. The slopes on either side are scree clad and boulder strewn, with barely enough grass to support the sheep. The latter range all over the slopes of Shipman Knotts and the lower crags of Kentmere Pike to the left, and Buckbarrow Crag to the right.

Now the songs of chaffinch, robin, tit and warbler of the roadside hedges are replaced by wheatear and meadow pipit. Tormentil flower among the grass bordering the rough, rocky road. Pheasants call from the slopes and a pair of mallards fly down towards Sadgill. From the beck comes the plaintive piping of a sandpiper.

The road begins to climb and the waterfalls in Cleft Ghyll, visited in Book One, lie to the left. The steep sides of the ghyll are white with mats of wood anemone and dotted with primrose, and the shading rowan and oak are in young leaf. An angry ring ousel flies from a rowan in the cleft across the road to a ghyll running down from Buckbarrow Crag.

Wood anemone

The road becomes very steep and begins to zig-zag, its surface cobbled. A huge, rocky outcrop on the right has distinctive wavy lines of sparkling quartz catching the sun. On the left is a railed fence replacing the wall and there is another railed area further along the road. Climb either and continue along the side of the beck. If these fences are missed continue to the end of the zig-zags to a metal, barred gate and climb over this to give access to the beck lying below the wall.

Ahead lies the confluence of the two becks, one issuing from Wren Gill and the other the young Sprint. The beck to the left has danced, and swirled, and struggled through the disused Wren Gill quarry. Now the walker sees it, just before it joins the Sprint, leaping ecstatically over rocky ledges to fall in one long curtain of foaming water beneath a rowan. The bubbling water then journeys along a narrow cleft over large pink and grey smooth stones to fall into a blue-green pool.

The Sprint, seen coming from the right, tumbles merrily around the boulders strewn along its bed, then falls in a pretty flurry of white water cascading over black ridges of rock before it drops into the same blue-green pool.

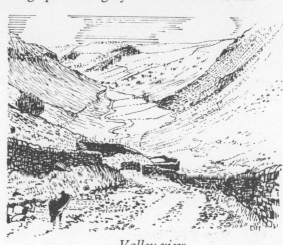

Valley view

The banks of both these delightful falls are clad in butterwort, moss, heather, saxifrage, wood sorrel and bilberry laden with pink flowers. A dipper busily runs into the water after a meal, and not until its beak is full does it fly off to its hungry brood. But here the overwhelming sound is the singing of the wren. Bursts of sweet song fill the air and the full, clear notes are louder than the chattering of the water. Truly Wren Gill is well named.

O.S. Map NY477084
5 miles

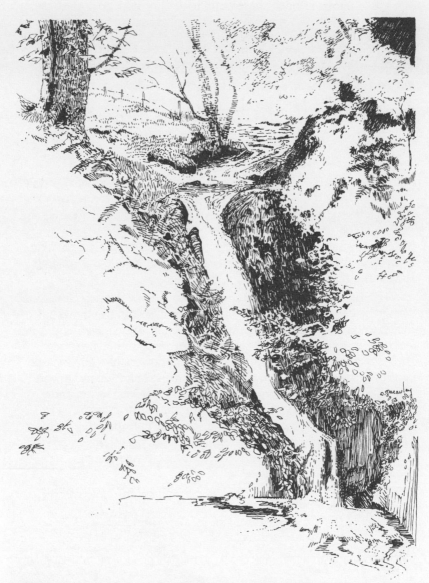

Waterfall on Hagg Beck,
Hagg Gill, north of Troutbeck

Waterfall on Hagg Beck, Hagg Gill, north of Troutbeck

L eave the car in a lay-by just north of the junction of the A592 and Holbeck Lane. Walk downhill taking a slip road on the left leading into the hamlet of Town Head. Turn left again down a steep, metalled track — Ing Lane — with access for pedestrians and horse riders only. This lane leads to Hagg Bridge from where tracks run into the valleys of the Trout and the Hagg. It is in the latter that the waterfalls lie.

In the third week of June wild flowers grow in great profusion, filling the verges of Ing Lane with a myriad of colour. Cranesbill, blue and purple, blend with bistort and vetch. Wood aven and water aven grace the roadside. Foxglove flower beneath the hawthorn hedge, itself bearing large, strong smelling flowers of 'May'. Large clumps of bird's eye give a blue haze to the ground below figwort, ragged robin, red campion and dog daisy. Overhead swifts and swallows chase innumerable insects that fill the summer air. The fields on either side support many ewes with plump, lively twins but, where the stock have not been allowed to graze, the meadows are golden with buttercup. Here and there along the lane the rose bushes have come into flower. Most are laden with deep pink flowers but occasionally the creamy-white flowers of the dog rose are seen. Bird cherry bear a large crop of webs full of black wriggling caterpillars but not too many to overwhelm the trees entirely.

Bridge with passageway

The lane crosses the Trout by a hump-backed bridge. It is constructed of drystone with an interesting passageway let into the west side. This allows sheep to move through from pastures on one side of the lane to pastures on the other without being able to stray. From the trees around the bridge a green woodpecker calls continuously, well hidden from view by lush foliage. A wren scolds angrily as the writer pauses, leaning on the parapet of the bridge. Beyond the bridge the lane is open on both sides but the grassy verges carry a mass of cow parsley with tall, delicate blossoms. Bluebell, red clover and shirt button flower among the parsley.

Take the cart-track that leads off to the right. To the left is a meadow of oats and away to the right cows feed in a field bright with buttercup. A yellowhammer calls its familiar song from the top of a solitary hawthorn bush. Turn left beyond the gate in the wall ahead and follow the wide, grassy track that sweeps into the valley of the Hagg. For most of the way it keeps close to the wall, which is much used by wheatear and pied wagtail.

A short distance along the track brings the walker to the bottom of a series of pretty falls. Higher up the slopes the beck can be seen dropping in a long, white jet before disappearing beneath a clump of ash lining its banks. It then falls in another long, white plume and then another. Finally it descends in lace-like cascades before rushing across the track, which must be forded to continue into the valley. Fifty yards along the track another beck races urgently downhill across the path and this must be forded too.

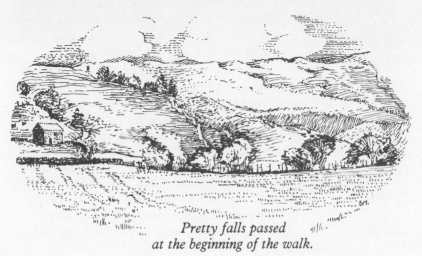

Pretty falls passed
at the beginning of the walk.

93

Forget-me-not carpet wet hollows on either side of the track, together with tormentil, milkmaid, spearwort and thistle. High up on Lowther Brow several red deer graze, raising their heads regularly to listen and smell, their antlers downy with velvet. The track comes close to a wood that slopes steeply downwards to the Hagg racing noisily below. A cuckoo calls and a willow warbler sings its sweet song.

Beyond the wood Troutbeck Tongue lies to the left. To the right rise the very steep slopes of Yoke and Ill Bell, the latter with several cairns on top. The Hagg hurries through the valley bottom with many foaming falls and cascades, the water sparkling in the afternoon sunshine. Butterwort, now resplendent with delicate purple flowers, covers a large wet area just before a disused quarry. Here too grows the delicate alpine campion. Beyond the quarry-waste the path drops down to a footbridge, edged with kingcup, across the Hagg. Continue along the path on the other side to a gate in the wall. Turn left onto the gated wide path that leads down to Troutbeck Park.

The track comes close to the wood passed earlier and then moves away, with open pastures on either side. At this point move across the grassy sward to the left, aiming for the wall ahead. Climb over a fenced gap in the wall then turn left and climb another fenced gap. Walk to the right, keeping close to the wall and with great care, move over to the edge of the ravine. Below lies the reward of the walk. The Hagg, having earlier shown some petulance deep among its wooded surrounds, now leaps over

Cow parsley

a precipice to fall many feet in one long, white, foaming torrent. Spray, tossed far and wide into the hollow, falls on the luxuriant vegetation. Fern, moss, liverwort, ramson and cow parsley cover the woodland floor, each plant with leaves spread wide to catch the light. Above grow rowan and hawthorn in blossom, elm almost over-burdened with papery-winged seeds and sycamore now with the dark green leaves of summer. The beck thunders over its great drop into a dark, surging pool far below and then saunters casually over its rocky bed. It continues on, leaving the trees behind, passing under Hagg Bridge to join and swell the Trout.

The walker too, after returning to the open pasture, should follow the beck to the bridge that can be seen at the bottom of the gentle slope. Walk on along the metalled track to Ing Bridge and Ing Lane.

O.S. Map NY425056
4½ miles

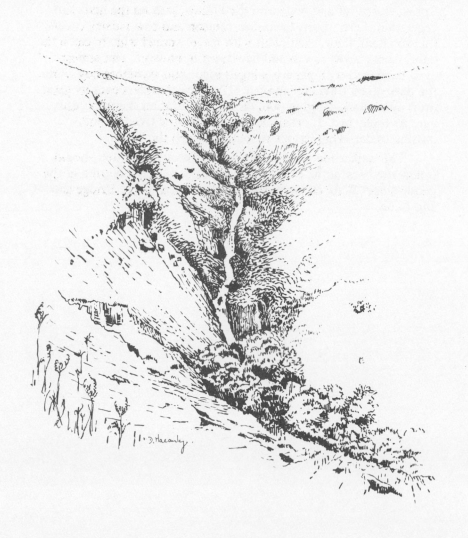

Waterfalls on Hopgill Beck and Rowantreethwaite Beck, Haweswater

O n the longest day of the year, the roads leading to Haweswater Reservoir are edged with a mass of wild flowers. Dog daisies, tall and white, dominate the verges. Among these, shrubby hawkweed, pink campion and cranesbill add small, vivid patches of colour. Above, in the hedges, dog roses flower. Climbing over the rose bushes is honeysuckle, fragrant with blossoms. Nearer the lake the limestone walls are bordered with cow parsley. The meadows around Bampton Grange and Bampton are a cloud of pale yellow, with buttercup, dog daisy and wild mignonette obscuring the green grass of spring.

Beyond Bampton, the well signposted road passes along the east side of Haweswater. It runs below fells that are losing their dead vegetation. Stunted hawthorn, wizened throughout the winter, are glorious with a huge canopy of white blooms.

White-topped becks in spate race headlong downwards on either side of the lake. They provide the plentiful supply of water which led to the choice

Dog rose and dog daisy

of this beautiful valley as the site for a reservoir and the resulting sad loss of Mardale Green.

The road ends with a small car park. Here wheatear abound. They call from rocks close by, feed their young and disport with each other, flashing their white rumps as they fly, quite unconcerned by human intruders. Common sandpiper call. One sits on a great rock and utters its long, thin whistle, another chooses the top of an old wall to give its rippling call, but neither is ever far from its reach of the beck. Meadow and tree pipit, trilling cheerfully, rise upwards into the low mist that cloaks the fell and which occasionally descends to the valley bottom.

A footpath leads from the car park back along the shore below the road. Across the narrow stretch of water lies the promontory, the conifer-clad Rigg. Opposite Wood Howe Island the path leads up to the road and on the other side a signpost has the legend:

> Old Corpse Road
> Public Footpath
> To Swindale

This indicates the route to take for the best view of the waterfalls on Hopgill Beck and Rowantreethwaite Beck. This is a glorious path to follow, each zig-zag giving a new view — sometimes the awesome grandeur of Harter Fell, High Street and Branstree, sometimes the peaceful water below and very often the fury of the waterfall in Hopgill.

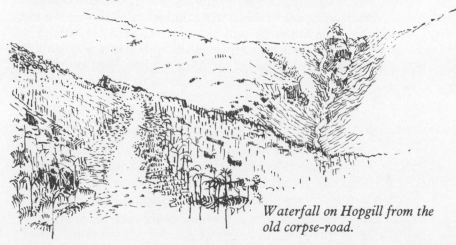

Waterfall on Hopgill from the old corpse-road.

The path is turfed for some of the way and is pleasant to walk along, but at each corner of a zig-zag the surface becomes rocky and these hindrances jerk one's thoughts back in time; back to the first quarter of the eighteenth century when the last corpses were taken along this route to Shap for burial, because there was no church in Mardale at that time. As the mist comes down and wisps of damp air touch the face it is easy to imagine the clop of horses' feet and the shouts of the drovers negotiating the sharp turns.

Old corpse-road

Suddenly, a commotion on Wood Howe Island, now just a floating raft of conifers far below, brings one back to reality. Dozens of common gulls and lesser black-backed gulls rise with raucous calls from their daytime roost to circle and settle again. What has unsettled them? It is not the cormorants on the far end of the island, "drying" their wings like heraldic dragons. It is a buzzard winging across to the Rigg.

Tormentil, bedstraw and butterwort colour the fell on either side of the track and on the drier scree foxglove are in full bloom, but all the time the eye is drawn from this delicate loveliness to the stately falls ahead and to the right. Hopgill Falls are seen first. From the top, white water leaps exuberantly downwards under a rowan laden with creamy blossoms, and then continues to tumble for a long way, foaming, raging, plummeting, roaring, deflected first to the right and then to the left until a huge boulder projecting upwards in the path of the beck divides it into cascades that are momentarily lost to sight under sycamore and rowan. Eventually the beck races towards the bridge carrying the road, then under the path taken earlier, to lose its vitality in the waters of the lake.

It is a breathtaking spectacle. Yet another glorious waterfall can be seen at the corner of the second zig-zag. The fall on Rowantreethwaite Beck is more secluded in its tree-lined gill but

nothing hides its spectacular plunge from the top and here and there, through gaps in the trees on its journey downwards, the foam-toppped water can be seen piling up above the narrow cuttings in tremendous, frothing masses.

Below, where the two becks converge, there are grassy flats for afternoon naps and summer picnics. A redstart flashes its fiery red tail as it flits across the clearing.

O.S. Map NY483117
2½ miles

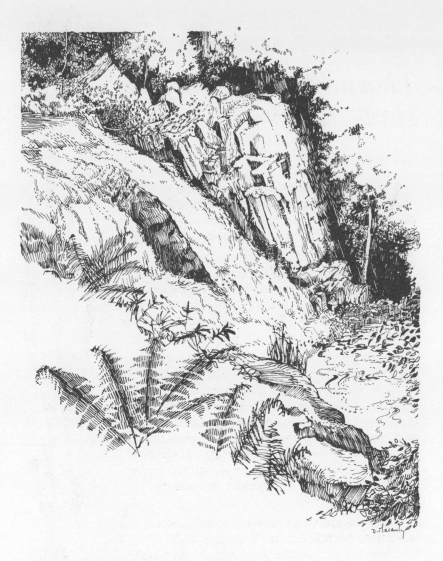

Thornthwaite Force,
Haweswater

Thornthwaite Force, Haweswater

A shady walk to a lovely waterfall on a chattering beck is a perfect choice for a scorching June day. Thornthwaite Force is the fall, and it lies on the Haweswater Beck, north-east of Haweswater Reservoir.

The roadside verges on the journey to the Force are now rich in wild flowers. Dog daisies bloom and provide a pleasing backcloth to pink, blue and purple cranesbill. Bistort and vetch add to the riot of colour.

Driving along the lanes early in the morning to avoid the intense mid-day heat, one is likely to see a barn owl still abroad or a jay busily seeking food for its brood. Yellowhammer flit across the road from hedgerow to hedgerow and one male is already prostrate on a stone on top of a wall enjoying the sun. A male pied wagtail with wings outstretched and tail extended appears twice its normal size as it seeks to intimidate an intruder too near its nest in the wall.

Park on the verge beneath a shady hazel just before Naddle Bridge. Take the ladder stile over the wall on the south side of the road. Turn right and cross an ancient drystone bridge covered with grass that must have been in use many years ago. It runs parallel with the modern bridge and is a fine structure.

Dog daisy

Cross by a wooden bridge to the far side of the beck where cows and their calves graze and one large, white bull slumbers away under an oak. The meadow is full of buttercup and rooks caw in the distance.

Turn left and follow the footpath — a permissive path and part of the Coast to Coast Walk — that runs beside the merry beck. Here alder, oak, ash and hawthorn lean over the water. A plank footbridge carries the walker over a tributary beck and here pink clover grow.

Just before a wall is reached the first view of the Force is obtained. Here the beck makes its foaming descent through bracken, buttercup, meadow sweet and yarrow. Under alder, oak and birch it tumbles downwards in a long cascade.

Climb the ladder stile over the wall and walk on for a few yards. Scramble down the gently sloping bank to see the Force at its best. It falls in a curtain of white water sending spray out into the summer air. Myriads of droplets sparkle in the sunlight that penetrates the foliage above. Streams on either side of the main fall tumble down ladders of rock, and hanging gardens are kept lush by their spray. In these grow cranesbill, kingcup, herb robert and hawkweed. Here a wren scolds and a greenfinch calls from the top of a large oak that overtops all the other trees. A dragonfly flits across the water.

Continue along the path by the beck which encircles several small islands covered with cranesbill and meadowsweet. Cross

Cows in meadow

another plank footbridge over a wet patch of ground made blue by masses of forget-me-not. This part of the beck is the territory of a family of dippers. The mother, with a bright, white bib and chestnut-coloured lower breast, is very busy in the fast-flowing shallows catching insects for her three demanding young. All the fledglings are dark brown above, like their parent, but their bibs are a dull yellow and much less easily seen by friend or foe. They stand around on rocks, bobbing up and down and wait to be fed. Then, as if impatient with the delay, they get into the water with a splash and attempt to feed themselves.

There are two more footbridges to cross. Close by is a small rocky island completely covered with yellow touch-me-not, a patch of brilliant colour in the middle of this shady beck. Walk on along the path and then cross a picturesque drystone bridge that spans the Haweswater. Continue along a wide path through a small wooded area to a gate that gives access to a walled lane. Within fifty feet of this gate look for throughs on the left hand wall; these are easy to miss.

The path now winds across a hay meadow full of ripe grasses amongst which flourish buttercup, cow parsley, sorrel, lesser stitchwort, dog daisy, clover, birds-eye, daisy and yarrow. Take time to enjoy nature's profligacy here.

In the wall on the far side are more throughs and these lead to a hedgerow laden with dog rose, where a blackbird sings. The road is just ahead. Turn left and walk back a few yards to where the car is parked.

Bridge over Haweswater Beck

O.S. Map NY512160
1 mile

Waterfalls in Hayeswater Gill, Hartsop, Brothers Water

Waterfalls in Hayeswater Gill, Hartsop, Brothers Water

T o reach the waterfalls in Hayeswater Gill, start from the car park at Hartsop. The narrow lane to the village leaves the A592 on a bend at the north-east corner of Brothers Water. Before setting off, walk back along the lane to see some old stone houses with interesting galleries. Pass through the gate at the end of the car park and walk along a reinforced track. At first the noise of the tumbling beck is all that can be heard. Then the deep bark of ravens, circling with their young over Brock Crags, is heard above the sound of the water. A keening cry from high

Cottage with gallery

among the crags comes perhaps from the brood of a peregrine demanding to be fed.

Follow the path along the valley bottom, past cattle and sheep in the pastures. Ash trees lining the banks of the beck shade the gate and the walls and stand in clusters in the corners of the pastures. Swifts and swallows wheel overhead, linnets cross the valley with undulating flight, twittering as they go. Along the edge of the path grow ragwort, St John's wort, knapweed and harebell and in the verge-side pools, lesser spearwort thrives. The path soon rises well above the beck and is now lined with yarrow, clover, tormentil and buttercup.

Stand at the gate on the path and look down on the meeting of Hayeswater Beck and Pasture Beck, at the remains of old buildings, most likely part of the old lead mine. Pasture Beck flows gently down from Threshwaite Cove along Pasture Bottom, sparkling in the sun for all its length. Once through the gate leave the reinforced road and take a right fork that leads to the Hayeswater Beck. Young wheatear idle in the sun before migration begins.

Cross the turbulent, white-flecked beck by the wooden bridge, which is shaded by sycamore, and pass through another gate. The way is upward and the path very rocky. By the next gate, clumps of rush grow in the wet ground close to the path. Pause here and look back. To the left lies the sheer and desolate side of Fairfield, with its gullies, crags, precipices and ravines. Below lies Brothers Water, almost navy-blue as it reflects a storm cloud. Above the lake is St. Sunday Crag, with Coldcove Beck, foam topped, before it disappears into its tree-clad gill.

Bracken with short fronds covers the fell. The path continues to rise until a level area is reached. This overlooks the filter house and two foaming becks which race down Calfgate Gill and Prison Gill. Both becks have fine falls for most of their length. The filter house has eaves with overhanging gutters and these

Ragwort

provide nesting sites
for a large number
of house martins.
They dart in and out of
their nests and then wheel
across the gill, their rumps and
underparts white, their backs
steel-blue. To the right of the
filter house lies the beck in
Sulphury Gill which drops down
the bleak fellside in one long fall.
Then it slides over wide, flat rock-
faces in a curtain of white water. It
makes a loop through the bracken,
passes through a break in the fell wall and
joins the beck in Hayeswater Gill.

At a place where ash, hazel, silver
birch and rowan crowd together, the beck makes
a spectacular plunge in a great wide wall of
foaming water. All other sounds are blotted out
by its thundering as it tumbles into a hollow.
Here the vegetation is lush, heather blooms and
shrubby hawkweed brightens the dark recess. To
see this furious leap, leave the path and clamber
down the fell slope on the left. It is a sight not to
be missed. Then return to the path and continue
climbing. The surrounding fell has small patches
of bilberry and butterwort but is mostly covered
with bleached grass, rush, cotton-grass and
sphagnum moss, the latter holding an enormous
quantity of water.

*The way is
upward and
the path very
rocky.*

Then the lake — Hayeswater — is reached. The water is
blue-black as dark clouds hang low over The Knott, High Street,
Thornthwaite Crag and Gray Crag. Small, white-topped waves lap
the sides and water flows over the weir to hurry down the gill.
Bordering the edges of the lake are glacial deposits — huge humps
covered with grass and tormentil. An ideal spot for the day's picnic.
Circle the lake, there is a path all the way, then cross the bridge to
return along the rocky path. Just beyond the waterfall take a narrow

track that leads to the right. Cross the beck by a footbridge and climb the fell wall by throughs to follow the track past the filter house on to the road. This soon becomes a grassy track, easy to walk along and bordered with self-heal, harebell and yellow vetch.

On a drystone wall, a young willow warbler, olive-green in colour, captures insects on the wing. Close by the beck several young wren climb mouse-like over the rocks and sometimes try out their wings. They fly to a nearby rock and land in a heap of feathers. Then the gate overlooking the meeting of the two becks is regained. Here a flock of rooks are busy searching the pastures for earthworm, wireworm and leather-jacket. It is a short walk along the path to the car park. Up on Hartsop Dodd, trail hounds are silhouetted against the skyline and then, yelping noisily, they race down the steep slope on their return run to the trail's meeting, close by Hartsop Hall.

O.S. Map NY426129
4 miles

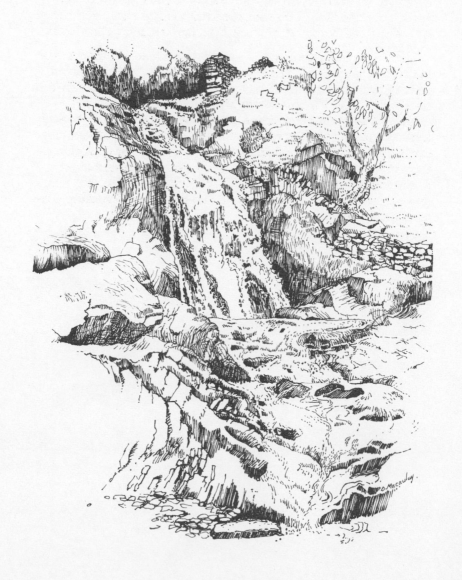

Waterfalls on Angletarn Beck, Hartsop, Brothers Water

Leave the car in the parking area at Cow Bridge on the Goldrill Beck at the north end of Brothers Water. Walk along the road in the direction of the Kirkstone Pass for a hundred yards and then take the left turn signposted Hartsop.

Turn left after the first building on the left and walk along the metalled road between low, drystone walls. To the left are the neat, green fields of the wide valley bottom in which sheep and cattle graze. House martin wheel and dart overhead and a pied wagtail chases an insect high into the air. A redstart, still lingering here in late August, flits across the road, its fiery-coloured tail attracting attention.

Where the road bears to the right continue along the unmade track straight ahead. The walls are

Angelica

higher and over these are hazel and oak. The verges are still bright with late summer flowers and here flourish knapweed, burdock, sneezewort, hawkweed, buttercup, betony, foxglove, figwort, cut-leaved dead nettle, meadow sweet, angelica, bramble, red woundwort, herb robert, enchanter's nightshade and scabious.

Where the ground opens out on either side of the road are oak, ash, hazel laden with nuts, holly, rowan, and guelder rose now in berry. Just beyond this open area the sound of falling water is heard and there, in the distance, are the falls.

Pass through the gate below a clump of alders onto the wooden bridge over the Angletarn Beck. From here there is a fine view of the elegant falls tumbling beneath birch, ash and rowan. The latter are heavily laden with large bunches of vermillion-coloured berries.

Climb up beside the sparkling beck, keeping to the left-hand bank. Here grow foxglove and harebell, and in the wetter areas butterwort, spearwort, eyebright, and sundew with tall white flowers.

The beck drops in two wide, white streams of water. Each is deflected by seemingly endless small ledges for all its length until it reaches a small, clear, blue pool. A clump of mouse-ear hawkweed grows high up under a rock overlooking the waterfall, brightening a dark corner. Delicate ferns grow in shady niches.

The path becomes quite steep and leads to the next fall. Here the beck plummets in a long, wide fall of water unsheltered by trees. Tiny droplets ricochet into the air catching the sunlight as they go. Stand here awhile and look towards Ullswater, its sailing boats resembling toys. Close beside the water lousewort flower with very pale pink blossom.

After a pause continue upwards, using the conveniently-stepped path. Beneath ash and holly, and between harebell and fern, the water races through a narrow rock gully and here a drystone wall comes very close to the water's edge. From just above the gully Brothers Water comes into view.

The climb steepens but there is a path all the way. Heather, marsh thistle, wood sage and toadstools grow close to where the water slides over great slabs of rock. The beck leaps headlong down three big rocky steps in a flurry of spray and much white foam.

Up and up continues the little path to the highest fall, where Angletarn Beck cascades in a curtain of white water between birch, rowan and hazel.

The way becomes less steep but small screes have to be negotiated and then the gill bears to the left. This is the point to cross the stream and to join a path that keeps close to the further side of a wall. This drystone wall, built so many years ago, continues up the gill on the edge of the beck. It is extremely well constructed and intact for much of its length. The path beside it, most likely used by those who built the wall, assists greatly in climbing the gill.

After half a mile's climbing, it is a joy to reach Angle Tarn and, at the point where the little beck issues forth, the wall ends. What a surprise it is, after having the gill all to oneself, to see on the other side of the placid water twenty or thirty picnickers who have arrived at the tarn by the more conventional route.

The tarn has several islands, inlets and bays and at its south end there is an extensive area of sedge. It is the haunt of trout and perch.

Cross the little beck that has provided the walker with so much merry accompaniment and climb the small crag ahead. From here can be seen the whole of Angle Tarn. Return to the track below and continue ahead to the much-eroded path used as a way to reach ridges and great heights.

Turn left and commence the long descent. From about fifty yards along this track it is possible to see both ends of Ullswater, Angle Tarn and Brothers Water all at the same time. Meadow pipits flutter ahead from rock to rock.

Angle Tarn

As the good track winds down towards Boredale Hause the views of the wide valley below become more extensive and very pleasing to the eye. At the Hause turn left, still descending steadily towards the sparkling and swiftly flowing Goldrill Beck. Away to the right lies Deepdale and further ahead is the start of the walk to Dovedale.

The track joins the farm track just before Dubhow Beck races downhill to join the Goldrill. And then the falls on Angletarn Beck are reached once more. A spotted flycatcher adroitly catches insects and above Brock Crags ravens wheel and dive and glide in the rising air currents.

O.S. Map NY408140
4½ miles

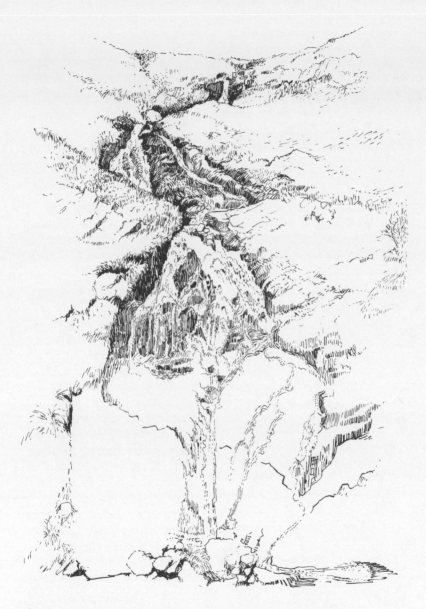

Waterfalls on Tongue Gill,
south of Grisedale Tarn

Waterfalls on Tongue Gill, south of Grisedale Tarn

The track leading to Helvellyn and Patterdale just beyond Mill Bridge is well signposted. It leaves the foot of Dunmail Raise Pass half a mile north of Grasmere. There is plenty of parking space on the wide grass verge on the west side of the road, opposite the track.

The path, once part of a busy pack-horse route, lies at first between drystone walls. Beneath these in early September grows great burnet with purple-brown heads. In less than a quarter of a mile a gate is reached, and once through this the beck, previously only a noise, can be seen sparkling and dancing over its rocky bed. The track begins to rise steeply, leaving the beck far below hidden among ash, oak, sycamore, cherry and rowan. The latter are laden with large bunches of rich red fruit and through these blackbirds blunder as if drunk on rowan juice.

The steep slope down to the beck is thickly covered in bracken tinged with brown. Overhead flits a

Rowan berries

dragonfly enjoying the warmth of a perfect September day. The verges of the path are spangled with colour where hawkweed, tormentil, foxglove, marsh thistle, spearwort and buttercup flower.

Another gate gives access to Little Tongue Beck and this can be crossed by large, conveniently-placed boulders or by a bridge if the beck is in spate. Turn right and cross another footbridge. This spans Tongue Gill Beck just before both streams come together. Between the two becks lies Great Tongue, an extensive area of high ground densely covered in bracken.

Follow the path from the footbridge and continue along it keeping close to the tumbling water. As it begins to climb gently, it passes through dying bracken now almost completely brown. The path is frequently bisected by side streams flowing through bright green flushes and in these flower mossy saxifrage, butterwort, forget-me-not, sheep's bit and eyebright. There are clear pools along the beck between falls and these are edged with heather and male fern.

Where the little beck noisily flows through a small gorge some scrambling is required, but the path, at times indistinct, follows the easiest route. A rowan shades the water, and bilberry and mountain fern flourish beneath. Once beyond the little ravine and its pretty falls strike up right and join the well-trodden path above. Use this path after a spell of prolonged rain when the beck-side path can become very wet indeed.

To the left towers the distinctive craggy top of Seat Sandal and over this circle a pair of ravens. When a buzzard lazily glides overhead the ravens set off and mob it until it leaves their rocky heights.

Beyond lies a steep slope badly eroded by weather and walkers. Climb half way up this and then bear to the left across the bleached mountain turf to the edge of the beck. It hurtles over a ledge above and falls in a long, white jet. It then spreads out into a large fan-shaped cascade. This is repeated again before it swirls on through a narrow gap in the confining rocks beneath three splendid rowan. The sides of the tiny ravine are lush with heather, scabious, harebell, biting stonecrop and fern.

Climb up beside the beck and rejoin the very worn track. To the right lies another spectacular fall. Long white tresses of water

slide over water-blackened rocks, each droplet catching the sunlight as it falls into a dark pool at its foot. Here the charms of the beck are fully exposed; no confining rocks or trees hide its glory. From the foot of the tumbling water look back down the gill towards the slopes of Silver How and the quarry at Chapel Stile.

Refreshed by a rest next to the waterfall continue climbing. Stonecrop, self heal and lousewort grow in profusion just beyond the wide track of rocks. A sparrowhawk flies low overhead surrounded by a host of meadow pipits noisily urging it on its way. To the right, and below the path, lie large glacial humps, or drumlins, guarding what looks like the bed of an ancient tarn, Hause Moss. Still further to the right are the steep, eroded slopes of Fairfield Brow. Ravens, probably disturbed by the unusual number of walkers on the Horseshoe, fly from the Brow to the rocks on Seat Sandal, the noise of their wings very loud in the still mountain air.

The track continues to climb steeply. Parsley fern between the boulders is tinged with brown. And then the ridge is attained. Look back from here to Grasmere, deep blue in the afternoon sun, to Coniston Water, paler in the distance, and to the estuary and mud flats, almost colourless in the far distance. Look ahead to Grisedale Tarn, momentarily grey as a cloud obscures the bright sunshine, its placid waters only occasionally disturbed by fish below.

Falls above the path

A grey wagtail gracefully flies low across the surface and alights on a rock by the water's edge. A flock of young meadow pipits dance through the air enjoying the myriad of insects over the tarn. A short walk along the shore to the right gives a spectacular view of Ullswater, deep blue and distant. Across the tarn lie the slopes of Dollywagon Pike, deeply scarred by the zig-zagging path that leads to Helvellyn.

On returning, take a path to the right just before the waterfalls are reached. After a hundred yards or so look back to see where Tongue Gill Beck leaps over rock ledges and hurtles through narrow, steep-sided ravines. It has just negotiated a way through the drumlins.

Once the walker has scrambled over the rocky outcrops along the path, he finds a wide grassy swathe leading down the hillside to the bridge crossed earlier. Great Tongue and Little Tongue Gill lie to the left, and Little Tongue and the steep slopes of Seat Sandal to the right.

This is a delightful way to return, with the sun full in one's face and the view below of the neat, green fields of Grasmere clustered around the northern end of the lake.

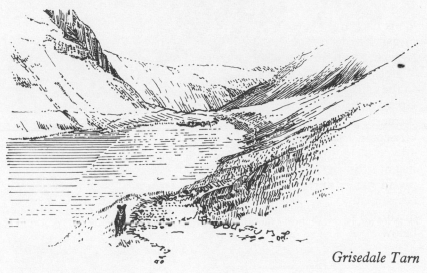

Grisedale Tarn

O.S. Map NY348111
5 miles

Waterfalls below Hart Side, Ullswater

F ollow the A592 along the edge of Ullswater, take the turn signposted Dockray and park in the Aira Force car park in a small wood on the right-hand side of the road. Cross the road, climb the stile and follow a path to the left through an oak wood at the start of Glencoyne Park. The grassy track climbs gently between bracken that is beginning to turn brown. Within a few hundred yards the walker has his first view of the lake, lying very still below, its glassy surface reflecting the steep fells.

Robin and great tit sing and hunt for spiders in oak that are as yet only slightly tinged with yellow, and tormentil flowers underfoot. As the path continues to climb, almost imperceptibly, the oak are replaced by birch and hazel, aglow in the autumn sun, each leaf a yellow banner. Mistle thrush move noisily through the branches of an elder laden with purple fruit, and a green woodpecker makes its presence known by its call and then flies off to trees farther up the fell. Several small becks, easily crossed with one step, tumble through the park, their banks clad with birch,

Robin in oak

hazel and bracken, all in their early autumn colours. A wren scolds as it is disturbed in the yellowing undergrowth. Here and there a buttercup is still in flower and a solitary rowan, brilliantly multi-coloured in the bright sun, grows close to the ascending path. Through a clearing in the trees more of the tranquil lake is seen.

Ash trees, laden with bunches of pale green keys but with no sign of their autumn garb, are the dominant trees now. The path passes through these and then on to another clearing. From here there is a superb view of Ullswater, both south to Patterdale and east towards Pooley Bridge. Soon, an alder copse is reached and the air resounds with the chuckling of young blue tit. Marsh thistle thrives in wet areas and just beyond, bugle, herb robert and lesser stitchwort flower. After crossing more open ground make for a stile in the wall that runs down the steep hillside to the lake. Once over the stile follow the grassy path through a beautiful wood of very old beech, their leaves copper and bronze. The rays of the sun, slanting through the branches, turn some to gold. A deep, rust-red carpet covers the woodland floor, and scattered among the leaves is a heavy crop of mast.

Beyond the wood the path skirts a craggy, scree-covered eminence with a solitary larch, mis-shapen but now glorious in its garb of golden needles. A raven flies overhead croaking gutterally. The path winds around the rocky protuberance and then climbs very sharply. Take the steep ascent slowly,

Marsh thistle

pausing frequently to look at the lake and the mountains veiled in mist. The path is well cairned and occasionally flanked by a wind-blown larch but soon the trees are left behind. Through the gap in the fell wall lies a well-trodden track. Turn right and follow this for a few hundred yards and then take a narrow, indistinct path that leads to the right. When the path ceases, the walker must cross the rough fell, following the direction taken by the wall, which lies below him. In time, a good path is reached once more. The lake is left behind and the bleached grass, dead heather and spongy moss of Brown Hills lie all around.

The narrow path is easy to follow and stretches ahead to a ladder stile in a wall. To the right of the path the fell rises steeply and to the left falls away sharply to the valley of Glencoyne Beck, where the shining stream wanders round large glacial humps. The path, high up and safe, crosses scree, traverses springy turf and often becomes rock-strewn. It runs beneath Scot Crag to the edge of the white-topped beck that drops vertically to add its waters to Deepdale Slack. Beyond, dominating the valley, is the sombre mass of Glencoyne Head with its towering rock walls forbiddingly encompassing the head of the valley.

To enjoy the waterfalls, climb up the steep side of the beck to a remote hanging valley. Here, in utter seclusion, the little beck winds its way between grassy banks where

Continue on the well-defined path that runs above the wall.

barren strawberry still blossom. The beck falls gently at first before plummeting in a long jet of white water into a deep pool. It races on down an algae-covered slip-way before it fans out in white tresses and then cascades down the steep fell. This is a charming waterfall, set amid austere grandeur, strikingly different from the riotously-coloured fell slopes of the early part of the walk.

On the journey back, return to the gap in the fell wall, but instead of passing through continue on the well-defined path that runs above the wall. It skirts Swineside Knott and the extreme edge of Watermillock Common. Keep close to the wall all the way to the road. Then take a path through a gate on the roadside on the right of the disused quarry car park. This was once an old road and it leads to another gate opposite Aira Force car park, avoiding a tedious walk along the present road.

O.S. Map NY360191
7½ miles

Waterfalls on Caudale Beck, near Brothers Water

Waterfalls on Caudale Beck, near Brothers Water

November, and the tree-clad fell slopes of the Lake District are a magnificent gold and bronze. The sides of the lanes around Ambleside are filled to overflowing with sienna-coloured leaves, and more leaves are blown hither and thither by the lively breeze. On the drive up the Struggle to the Kirkstone Pass Inn the ash and rowan are now stripped bare of their leaves and the symmetry of their branches charms the eye. A mile and a half beyond the inn, in the direction of Brothers Water, the Caudale Beck leaps and dances on its way to join the Kirkstone Beck. To see the waterfalls on this beck is the object of the walk.

There is a small parking area on the east side of the pass just beyond Caudale Bridge. Walk for a hundred yards along the grassy verge towards a stile in the wall and a signpost. Once over the stile bear to the right to the side of the racing water. Before starting the climb through the gill

Bottom of the first fall

look back at the lovely old bridge, exquisitely constructed in stone, and to its guardian field maple still retaining its bright yellow leaves.

On the wall beyond the water yellowhammer, with heads the colour of the maple leaves, pause and chatter before flying off across the pastures. A solitary crow alights on the same wall and then it too takes off to wing across the dying bracken.

A few steps along the side of the beck bring one to the bottom of the first fall, where white-topped streams drop over black boulders. The raging water is then channelled between enormous, squat rocks that cause it to pile up in boiling foam before it hurries on its way to the bridge below. Just above the fall is a wide, flat, grassy area bordered with mountain fern and parsley fern resplendently green. Earlier, alpine lady's mantle flowered in profusion here and now its tiny leaves are tinged with red and lemon.

Follow the narrow trod as it ascends the gill, passing leafless ash and rowan, and holly and rose laden with berries. Heather still flowers and tiny buttercup spangle the dying grass. Just beyond the trees the Caudale makes another elegant fall, with two long, white jets tossing spray into the air. Leaning over the blue-green pool above the waterfall is a willow densely covered in saffron-coloured leaves.

The tiny path is not easy to follow, but it is the only way to ascend the north side of the gill to see the waterfalls at their best. Another fifty yards and a third fall is reached overlooked by a solitary rowan. This tree has shed all its leaves and its berries have gone too. Many of these are scattered over the fell, dropped perhaps by one of the many flocks of mistle thrush that are seen flying overhead.

The tiny track leads up into the seclusion of the fells. To the left the steep slopes are covered with bracken, now a rich-chestnut colour. To the right are even steeper slopes with scree and rocky outcrops and bleached grass wherever it can maintain a hold. Look back to the snow-dusted tops of Dove and Hart Crag. Beyond them both is Fairfield, all white, with several inches of snow. Below in the little gill beneath an ash tree is a long rock slide down which the Caudale rages in a great fury, losing its anger in a large, deep, turquoise pool. Juniper hugs the far bank of the beck, low growing and covered with dark blue-green foliage.

Away to the right, fifty yards beyond the slide, the beck is seen racing white-topped down Caudale from Caudale Head. Beside it on its left bank is a wide, grassy, heathery track used much more in earlier times than nowadays. It is worth finding this to ascend the steep gill and to be able to enjoy the lovely falls far below in the narrow valley bottom. To reach this path cross the feeder stream whose waters swell the Caudale, having been gathered from the slopes on the north side of Caudale Tongue.

Below, there are glorious cascades, there are twin jets of foaming water and there are stepped rocks down which the silvery water plummets. All around is the noise of falling water, the only noise in this secluded valley, sheltered from the winter winds that rage overhead. The indistinct track zig-zags up the slope and then continues on towards Caudale Head.

A pleasant way to return is to cross the Caudale at its confluence above the slide and then to follow a good track high above the beck, where marsh thistle still flowers. Ahead and below lies Brothers Water, a steel-blue sheet of water reflecting the golden-leaved larches on the slopes above. The sun shines fleetingly, turns the dead bracken to bronze and catches the white waters that slash the slopes of Dovedale and Caiston Glen.

O.S. Map NY404116
2 miles

Ash tree and Brothers Water

Fordingdale Force, Measand Beck, Haweswater

Fordingdale Force, Measand Beck, Haweswater

Park on a convenient grass verge just before Naddle Bridge, at the north-east end of Haweswater. Climb over the metal bars and descend the row of stone steps by the bridge on the right-hand side of the road. These give access to a piece of glorious, ancient oak woodland. The November sun, low in the sky, slants through the trees, lighting up the yellowing oak leaves and highlighting the golden-bronze leaves of beech trees that are scattered thinly throughout the wood. A flock of young blue tit chatter as they hunt industriously for food and a tree creeper calls loudly as it too searches. The track through the trees is part of Wainwright's Coast to Coast Walk.

At the edge of the wood, turn left and walk fifty yards along a metalled road, then follow a signposted road that bears off to the right. Within a hundred yards it ceases to be metalled and winds uphill through larch laden with a huge crop of cones and arrayed in a mantle of gold needles. The path is covered with needles, deadening footsteps and soft to walk on. Harebell flower on the verge. At the plantation edge, climb a stile and turn left along a wide bridlepath that leads towards the north-west shore of Haweswater. To the left, conifer continue, with hawthorn, rose and holly at the edge, covered with glowing berries. Through a ride that runs downhill on the left, the wall on the huge dam is seen. Overhead a kestrel hovers, the sun catching its chestnut feathers and the black tips of its wings. Through the branches of the trees the sparkling waters of the lake are almost colourless in the brilliant sunshine.

From a larch a red squirrel looks down at the walker and then scurries up to a higher branch. After another look it climbs again and then settles close to the main trunk, folding its tail over its

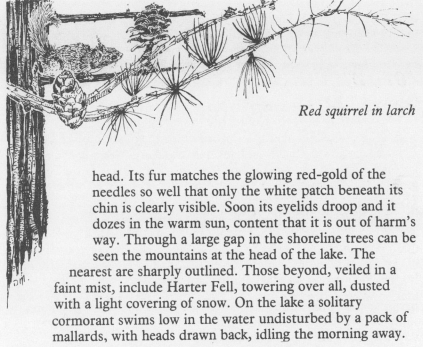

Red squirrel in larch

head. Its fur matches the glowing red-gold of the
needles so well that only the white patch beneath its
chin is clearly visible. Soon its eyelids droop and it
dozes in the warm sun, content that it is out of harm's
way. Through a large gap in the shoreline trees can be
seen the mountains at the head of the lake. The
nearest are sharply outlined. Those beyond, veiled in a
faint mist, include Harter Fell, towering over all, dusted
with a light covering of snow. On the lake a solitary
cormorant swims low in the water undisturbed by a pack of
mallards, with heads drawn back, idling the morning away.

The pleasant path keeps close to the lake until the Forces,
described earlier in this volume, are reached. These waterfalls are
close to the outlet of the Measand Beck into Haweswater. Cross
the footbridge and strike up the fell by a rather indistinct path that
keeps close to the racing water. Young blue tit call from the leafless
ash trees and colourful rowan, and a pair of buzzards circle
effortlessly high in the cloudless blue sky. The path beside the
tumbling water is steep and rocky but above the fall a sheep track
through the bracken leads more easily to a wooden footbridge.
Cross the bridge and follow a clear track through the dead bracken,
to the left. This continues beside the Measand well above the
marshy environs of the beck, with the steep slopes of Bampton
Common above.

The path leads to the jagged-edged Force Crag, which guards
the steep, rocky cutting down which the Measand leaps
tempestuously, creating Fordingdale Force. The water comes over
a ledge of rock in two long, white jets of water to fall in a foaming

mass into a pool before falling again in two more white streams into another pool. It then races down a wide channel in the rock, before swinging away to the left and dividing once more into two white falls which continue as separate streams, only to rejoin fifty yards along the marshy Fordingdale Bottom. A dipper flies rapidly and straight into the rushes below the Force as the walker disturbs it feeding in the fast-flowing water.

By midday in early November the large bulk of Long Grain casts a deep shadow over the Force but nothing can dim the beck as it dances down the gill past several rowan still wearing their autumn garb, and spearwort and scabious in bloom. On the return journey, take a track leading away from the bridge across the fell. It passes above a small larch plantation and an even smaller planting of mixed beech and larch. For most of the way it is easy to follow as the deep ruts of a tractor are visible. The track joins the main path by a rowan and an ash tree. Here, where foxglove flower in the full November sunlight and out of the wind, is a large round stone which makes an ideal seat for a picnic or a snooze before making your return journey.

Fordingdale Force can still be reached even when the mountain slopes around Haweswater are deep in snow. Then the racing mountain stream is bedecked with huge icicles and fantastic, fabulous ice-formations.

Harter Fell

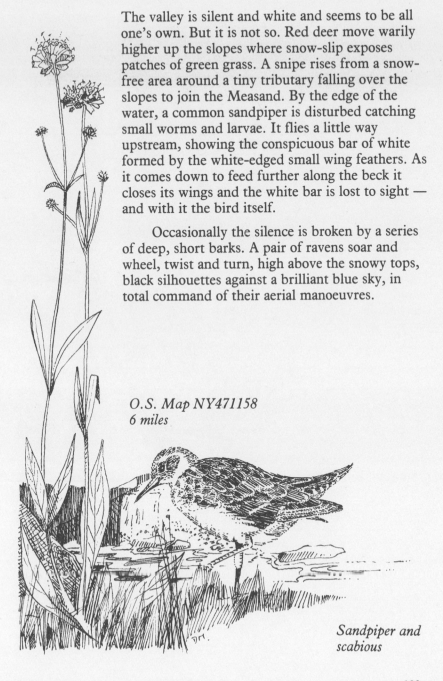

The valley is silent and white and seems to be all one's own. But it is not so. Red deer move warily higher up the slopes where snow-slip exposes patches of green grass. A snipe rises from a snow-free area around a tiny tributary falling over the slopes to join the Measand. By the edge of the water, a common sandpiper is disturbed catching small worms and larvae. It flies a little way upstream, showing the conspicuous bar of white formed by the white-edged small wing feathers. As it comes down to feed further along the beck it closes its wings and the white bar is lost to sight — and with it the bird itself.

Occasionally the silence is broken by a series of deep, short barks. A pair of ravens soar and wheel, twist and turn, high above the snowy tops, black silhouettes against a brilliant blue sky, in total command of their aerial manoeuvres.

O.S. Map NY471158
6 miles

Sandpiper and scabious

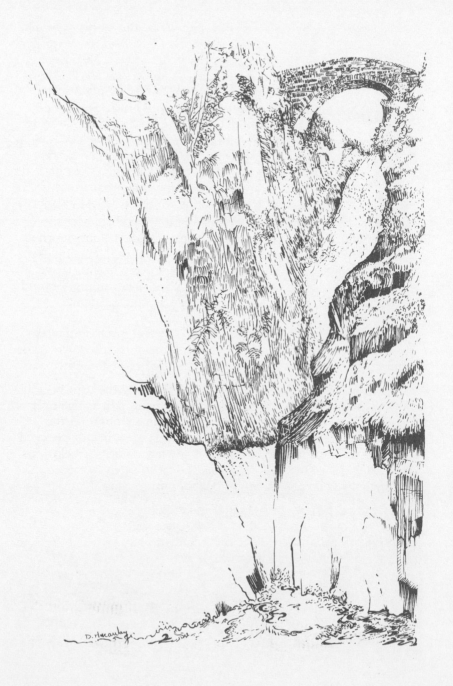

D. Macaulay

Aira Force and High Force, between Patterdale and Pooley Bridge, Ullswater

In mid November the Kirkstone Pass can be bathed in mist, taking away the tints of autumn on the fells. Once over the top, with Brothers Water lying below, see the colour return as the mist is left behind making the red-brown of the dying bracken and the green of the still-growing grass seem very bright. Drive through the pass and through Patterdale and Glenridding. Beyond, the road keeps very close to the shore of Ullswater, passing through Glencoyne Wood, where the burnished bronze of the beech is unbelievably beautiful. The willow and birch on the lake shore have shed their leaves, which gently float up and down in the water as the lake ripples, catching what little breeze there is.

The National Trust car park lies just beyond the turn-off for Dockray. A path leads through two kissing gates to a bridge over the Aira Beck. A huge sweet chestnut tree almost obscures the track with its recently shed large yellow and green, deeply-serrated leaves. The lower path keeps the beck in view. It lies far below, its noisy progress muffled, allowing the walker to listen to the chaffinch, tit and rook calling in the late autumn sun.

Gradually these sounds fade, and only the thundering of the Force can be heard. Once the drystone bridge is reached the full grandeur of this most spectacular fall is revealed.

Autumn

135

Alder

A tremendous surge of water plummets downwards, hissing noisily against confining rock-faces. The air is filled with myriads of droplets, each one acting as a prism, so that rainbows constantly form and re-form over the water. The red and orange of the bows flicker like flames as the spray bounces irregularly. After the water falls into a deep brown pool, another fierce jet cascades over more jagged boulders.

All this energy is trapped within a gill lined with oak, which still retain their lemon-coloured leaves. They, like the spray, catch the sunlight. A path climbs to another drystone bridge — this one over the top of the falls. Here there is a plaque with a moving memorial to two brothers who died in the service of their country. From here one can look down on the spray filling the gill. Cross the bridge and continue along a path beside the Aira, through hazel where great tit and tree creeper fill the grove with their distinctive calls. A red squirrel feeds on the huge crop of acorn. Some acorns are already germinating and showing the red of their inside casing.

From a knoll above the hazel the first snows of the year are seen on the fells, high above the lake. At the next bridge the Aira shows much petulance as it races through narrow canyons and over small precipices but not in such a way as to prepare the walker for what lies ahead.

The path now runs between the beck and a drystone wall, past alder that trail their roots in the water. Some have lost their leaves and through the bare branches is seen a huge, wide, white curtain of water. It is High Force. The foaming, surging water

races across a high, wide wall of rock and is then channelled into a narrow, precipitous cleft. As the water builds up to negotiate this narrow passage it boils, swirls and rages. Where it has continually tumbled and hurried through the imprisoning walls it has gradually undermined them, forming caverns through which it hurtles.

These two falls, Aira Force and High Force, viewed after rain and when in spate, are gems to be savoured and remembered with joy.

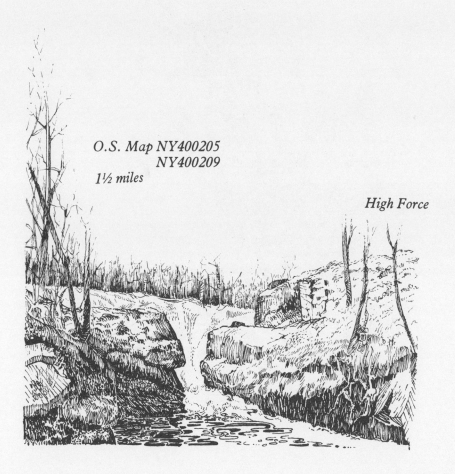

O.S. Map NY400205
NY400209
1½ miles

High Force

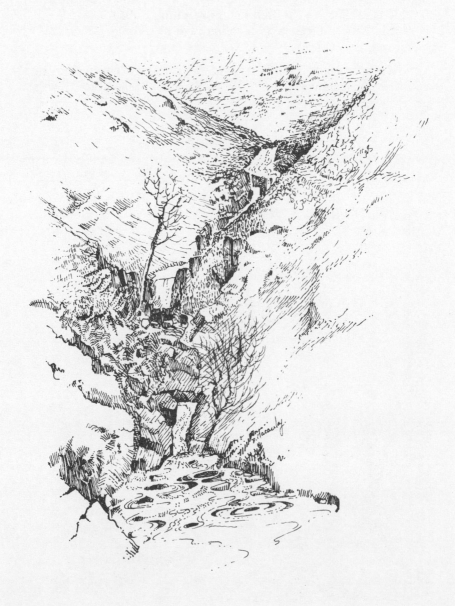

Waterfall in Greenhead Gill, Great Rigg, Grasmere

Early in December the oak around the village of Grasmere are a dull gold, the beech are a fiery bronze and the larch a soft yellow. The fell grass is beginning to turn a pale yellow with no sign of the bleached, withered grey yet to come. The bracken, quite dead, is a rich brown. Hips, haws and the red berries of honeysuckle and wild bryony glow like balls of red glass in the bright, clear, Lakeland air.

To reach the waterfall in Greenhead Gill, park next to the Swan Inn on the A591 north of Grasmere village, turn right and walk up the lane. The second turning on the right is walled and signposted to Greenhead Gill and Allcock Tarn. Take this turning, walking between the walls, with the sound of falling water but a short distance away. Soon the path comes close beside the merry beck, which tumbles in white foam over its rocky bed beneath beech, conifer, laurel and holly. Here deciduous leaves continually drift down, littering the lane and deadening footsteps.

The end of the lane is gated. Pass through and cross the plank bridge to the far side of the lively beck. Follow the indistinct path that

Bryony berries

at first keeps close by the wall, then rises sharply up the fell away from the beck. The steepest part is stepped, but sections of the path are badly eroded. In time the path levels out and comes to a bench seat sheltered by larch, oak and silver birch. Sit here and enjoy the view of the snow-capped north western hills beyond Thirlmere. To the left is a dark, sombre plantation of pine where coal tit and wren call in the afternoon sun.

The path continues, terrace-like, across the fell below Butter Crag. On both sides the dead bracken is a warm russet. Below in a wide-bottomed ravine, guarded by a single birch, is the Thirlmere aqueduct which crosses the chuckling, gurgling beck. Beyond, and high up, beneath the buttressed rock of Stone Arthur, are long, white jets of water hurtling down the richly-coloured fell to join the beck issuing forth from Greenhead Gill.

Keep following the track, which soon comes to the edge of Greenhead Beck, and then walk up the gill beside the beck as it flows wildly downwards from its rising beneath Great Rigg. Its water

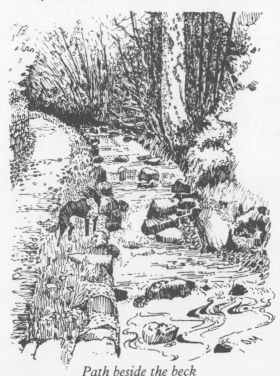

Path beside the beck

pauses momentarily in a crystal-clear pool tamed temporarily by a small concrete weir before it flows strongly over the barrier to cascade downwards beneath ash now bereft of leaves. This curtain of water is divided by a projecting boulder but the streams are soon reunited to flow fast and furiously as one. Again the waters are parted, this time by a small island, where an ash, still with its leaves, grows beside a rose tree laden with glowing hips.

140

The beck continues through the steep gill, its sides sloping sharply, covered with grass and bracken. Holly and willow flourish close to the water and the rocks flanking the stream are covered with moss. On the opposite bank, by the lowest fall, is a little cave overhung with turf and heather.

These charming falls, hidden by a bend in the stream until one is nearly upon them, come as a delightful surprise. To return keep to the side of the beck, passing by the edge of the turf-covered aqueduct, and then return to the gate at the fell wall.

Moss, wren and holly leaves

O.S. Map NY347085
1½ miles

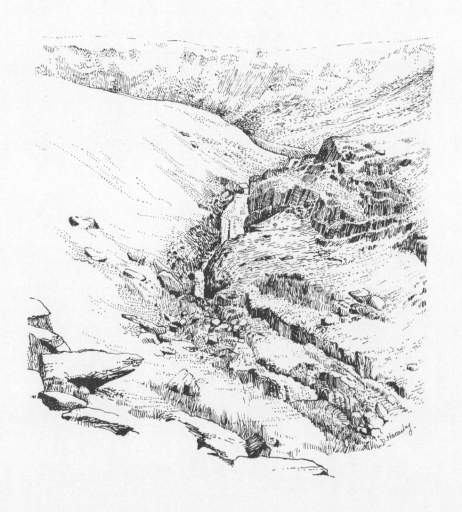

Waterfall on River Kent below Hall Cove, Kentmere

After a wet night the Lakeland air seems washed clean and distant buildings, fells and crags stand out startlingly clearly. Towards the end of the year an unusually mild day with some thin sunshine is most welcome. Such a day is right for venturing into the upper recesses of Kentmere, to the source of the River Kent, which flows through Kendal and gives its name to the old town. The waterfall, the object of the walk, lies just below the spawning ground of this bonny river.

The road to the village of Kentmere is a joy to drive along, even though in winter the grassy verges are yellow and bleached and the bracken bronzed in death. It keeps quite close to the Kent for several miles. The beck in spate races over its stony bed and foams over rocky hindrances in a mass of white spray that sparkles in the early morning sunshine. The buds of the hazel, oak and ash that edge the lane are tightly closed and through these troop great and blue tit enjoying the milder weather.

Leave the car in a small parking area beyond the church. This can become very full so an early start to the walk is advisable. Walk along the lane past Latrigg Farm.

Sheep feeding in Kentmere

A fox sneaks across a pasture quite close to the farm buildings. Is it after the farm ducks or the many rabbits that play beneath scrubby bushes, encouraged out of their burrows by the sun? Vermillion rose hips adorn the hedgerows on either side of the lane.

Pass through the gate by the farm and continue along the metalled road. Galloway cattle joust for the best position by a byre full of hay. Ravens fly over to Raven Crag. Rocks and boulders are covered with lichen and foxglove leaves. Further along sheep, too, enjoy hay as a supplement to the thin fell grass. Beyond the next gate a charming waterfall drops in steps down the crags behind a small farmstead.

Continue along the lane deeper into the peaceful valley, which is enfolded by silent mountains, with gullies white with snow. Hollies on the fell and along the roadside are stripped of berries. At Hartrigg the metalled road ends and a wide, rough track continues. Smoke from the chimneys of the farm adds a homely touch to the valley. A rook prospects an old nest in the rookery in the Scots pine shielding the farm from the icy blasts that can blow down from the high peaks ahead.

Pass through the gate, following the signpost directions for the reservoir. Ducks from the farm have strayed onto the fell and gossip to each other. Coal tit whisper in the pines and beyond these trees a roe deer grazes with ears erect, never dropping for one moment its watchfulness for danger. Down by the racing Kent black ponies also graze. Just before the track runs below Rainsborrow Crag a beck comes racing down the fell in a series of white-topped falls. It passes beneath the track and rages on to join the Kent.

Walk through the spoil-heaps that lie ahead, and beside the restored quarry cottage. To the right are weirs down which water from the reservoir races. Further on is the grass-covered dam that holds back the still smooth reservoir water. Continue along the path that follows the contours round the lake. A raft of common gulls enjoy the midday sun, occasionally rising noisily, circling once and then settling in a group once more. Over their sharp 'kak, kak, kak' comes another sound, an excited howling and yelping. High up Ill Bell the foxhounds are racing over the rough terrain in pursuit of a fox.

Beyond the reservoir the path continues over the fell. To the right the waterfall in Lingmell Gill (visited in Book One) noisily tumbles down towards the reservoir. Ahead the lower waterfall on the Kent (also visited in Book One) boils and rages white topped when it falls and a soft turquoise as it hurries through its pools.

To the left a stream comes down from beyond Froswick.

Follow the tiny track as it climbs a glacial mound and then clamber along the slopes overlooking the beck. To the left a stream comes down from beyond Froswick, its waters swollen by melting snow. It hurries merrily and hastily to join the Kent. Continue climbing upwards, pausing to enjoy the view of the reservoir, now away to the right. Far above on High Street small figures seem to crowd the way, but in this quiet ascent to Hall Cove, where the Kent rises, one's only companion is a foxhound intent on joining its companions.

The beck leaves Hall Cove impetuously, falling in a wide curtain of sparkling water plummeting downwards, furiously flowing over rocks and boulders. Its waters rage on either side of a long, grass-covered, rocky outcrop before uniting once more to plunge down through a necklace of small blue pools.

Continue climbing to the top of the glacial hump in Hall Cove, below Mardale Ill Bell. From here can be seen several tiny

145

streams draining the steep slopes before coming together to hurry to the waterfall just visited. Here the River Kent is born.

The birth place of the Kent.

O.S. Map NY440095
9 miles

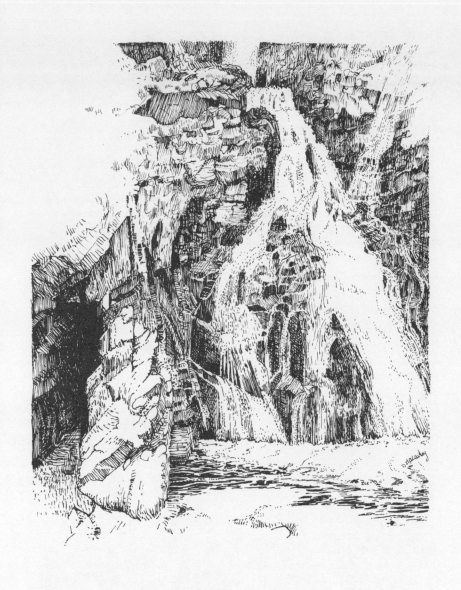

Waterfalls on Ruthwaite Beck,
Grisedale

Waterfalls on Ruthwaite Beck, Grisedale

Turn off the A592 on the south side of Grisedale Bridge and park the car against the wall as soon as a space is found. If this small area is full then the larger parking facility by Patterdale village hall can be used. This lies further south along the road. Do not attempt to continue along the lane towards the Grisedale valley because there is nowhere to park. The road is very narrow, and just exploring the lane by car could cause severe congestion and problems for the farmers who need to use it.

Continue on foot along the lovely lane, which climbs steeply between mossy walls. Ruddy-stemmed birch cradle the beck far below on the right and there are open pastures to the left. In late December the Grisedale Beck is in spate and it races white topped, eager to lose its energy in the lake. The trees seem full of small birds. Blue and great tit eagerly, and perhaps a little desperately, seek for food, urged on by the chill, searching wind sweeping down the valley from the mist-covered slopes above.

Drystone bridge near Elmhow

Elmhow Barn

The lane continues past a small plantation of larch and pine on the left. Surely this is the haunt of goldcrest in the summer, but now the trees are silent except for the wind tangling with the tops. At the gate across the lane keep straight on, obeying the sign set in the wall directing the walker to Grisedale Tarn. The lane is tarmacked and runs parallel with the burbling beck to another sturdy gate. Then it swings away to the right, crossing the beck by a striking drystone bridge. Beyond is the farmstead of Braesteads. The valley lies quiet and deserted and held tight in the grip of winter — gone are the bright colours of autumn and the rich brown of the dying bracken.

The track continues straight on and comes close beside the racing Grisedale. Ash trees with pale grey bark and tightly closed black buds grace its banks. On the other side of the water young jackdaws probe the soft soil of a meadow for worms and molluscs. The track is gated again. Beyond, the flattish ground on either side is covered with molehills. Here too voles abound and, at every small clump of longish grass, our dog poises with one foot raised and ears erect to catch sounds we are unable to hear.

Once beyond the next gate look for the little drystone bridge that carries a narrow path into the pastures on the other side of the beck. Here the blue-green water flows very fast, swirling against the roots of hazel growing along its banks. Tiny, stiff catkins give no hint of the soft beauty locked inside. Ahead lies Elmhow, a pleasing farmhouse. A pair of robins seem its only inhabitants. Behind is Elmhow plantation, through which tumbles a delightful waterfall. It drops over a steep rock face, brightening the shade cast by lofty pines.

Another gate gives the walker the chance to lean and watch the many figures far away to the right en route for Helvellyn via Bleaberry Crag and Red Tarn. Beyond Elmhow a barn lies across the path and a sign directs the walker to a gate on the left of the building. From here there is an excellent view of the waterfalls on Nethermostcove Beck visited at the beginning of the year. Soon the noise of the falls can be heard filling the valley as Grisedale narrows.

The good path continues beside another planting of Scots pine. Grass covers the ground below the widely spaced trees. A small stile in the bordering wall provides access — an ideal place to picnic out of the wind. Beyond the trees the path winds on over the open fell, past the sheep pens on the right. In the distance are Ruthwaite waterfalls, the object of the walk.

As the track begins to climb, the way is rocky and narrow but always easy to follow. Just before it begins to descend to the footbridge leave the path and walk down the grassy slopes to the edge of the Grisedale. Here it negotiates a steep drop in its bed in a series of charming falls foaming furiously through narrow canyons. Through the slats of the wooden footbridge the beck can be seen raging below. Cross the bridge, passing under the attendant ash tree. The rough path passes over a wettish area and then becomes a rocky track as it ascends the fell towards the Ruthwaite climbing hut. This has a plaque that says the hut was erected in 1854 and restored in 1887.

Ahead lies the path to Grisedale Tarn. On the opposite side of the valley is St. Sunday Crag, now

Polypody thrives beneath the trees.

shrouded in mist. Out of this come several ravens, gliding and soaring and occasionally performing acrobatics in the fast-moving air hurrying down the dale. When the mist lifts small figures are seen on the Crag.

Cross the bleached grass to the edge of the beck. From here the magnificent beck can be seen for much of its spectacular drop from Ruthwaite Cove until it races on to swell the waters of the Grisedale. In a flurry of foaming water it plunges in a steep fall over precipitous slopes. It then forms graceful cascades before descending in a short, white jet. Next it plummets in a long, streaming curtain of water to make its most dramatic drop into a deep pool. Spray caught by the wind is whirled away into the air and the noise of falling water is all around. It cascades once more into a deep-blue pool past a tiny cave on its left bank. Rowan grow and polypody, a welcome patch of bright green, thrive beneath the trees. When the mist lifts momentarily, High Crag and Nethermost Crag can be seen snow covered high above the falls and the cove.

O.S. Map NY355136
6½ miles